THE OFFICIAL COLORING BOOK

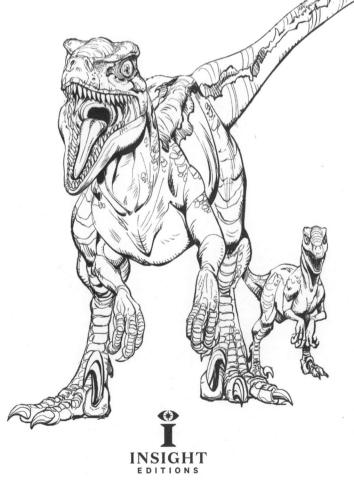

SAN RAFAEL • LOS ANGELES • LONDON

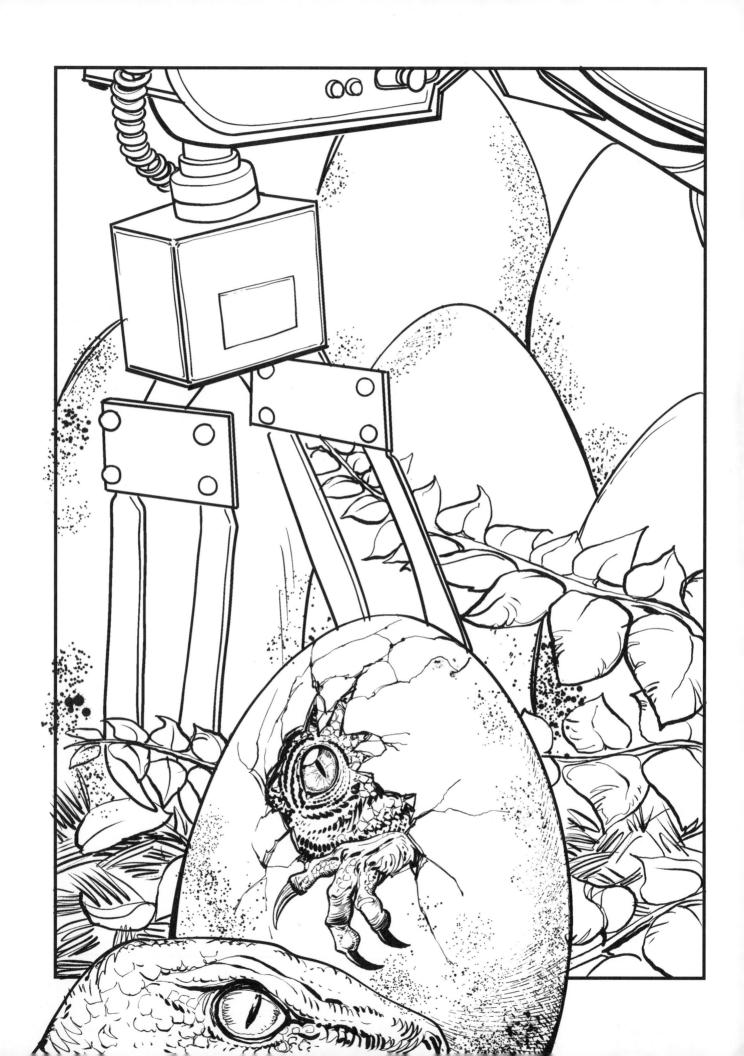

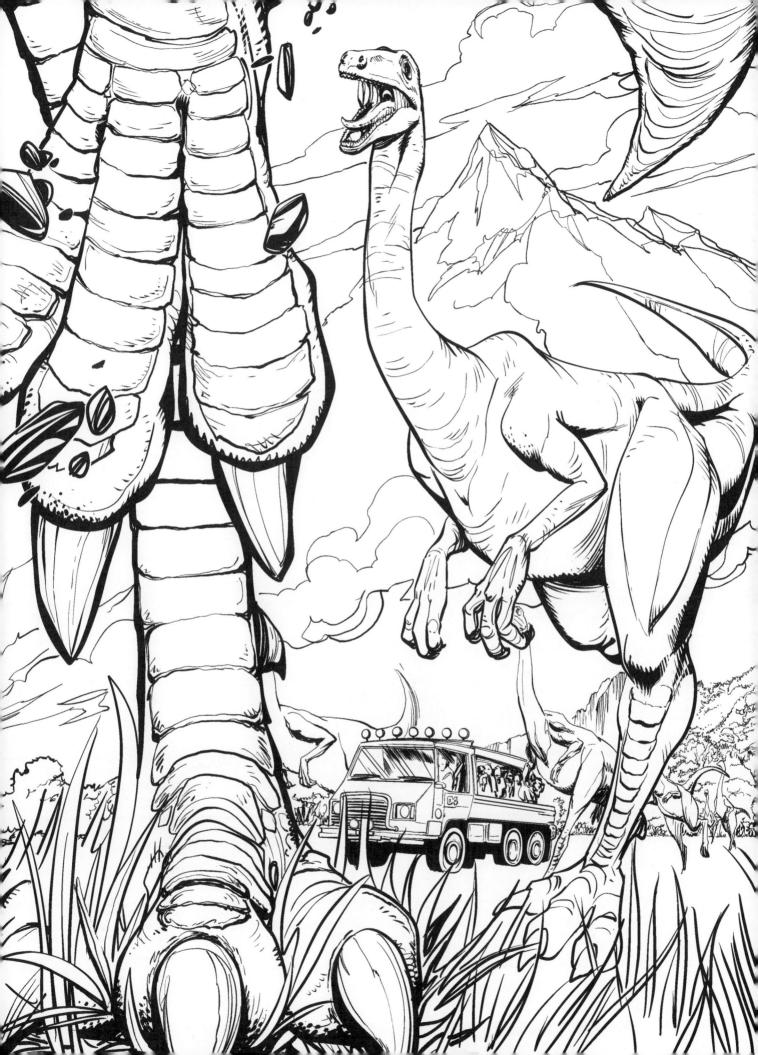

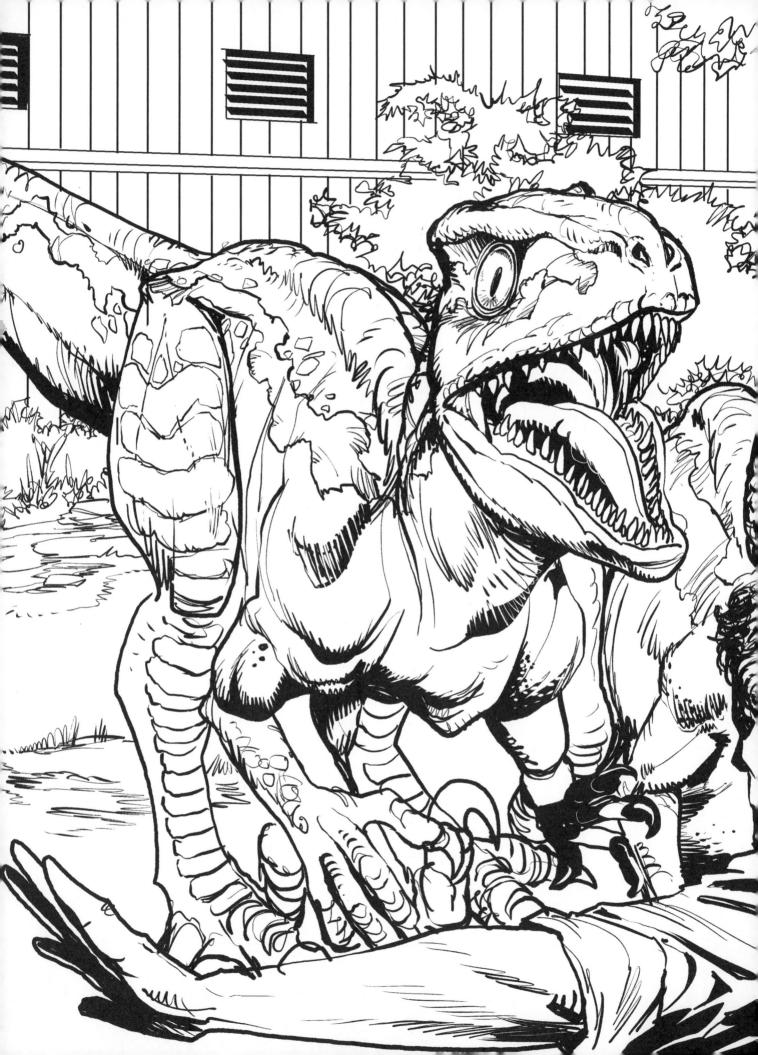

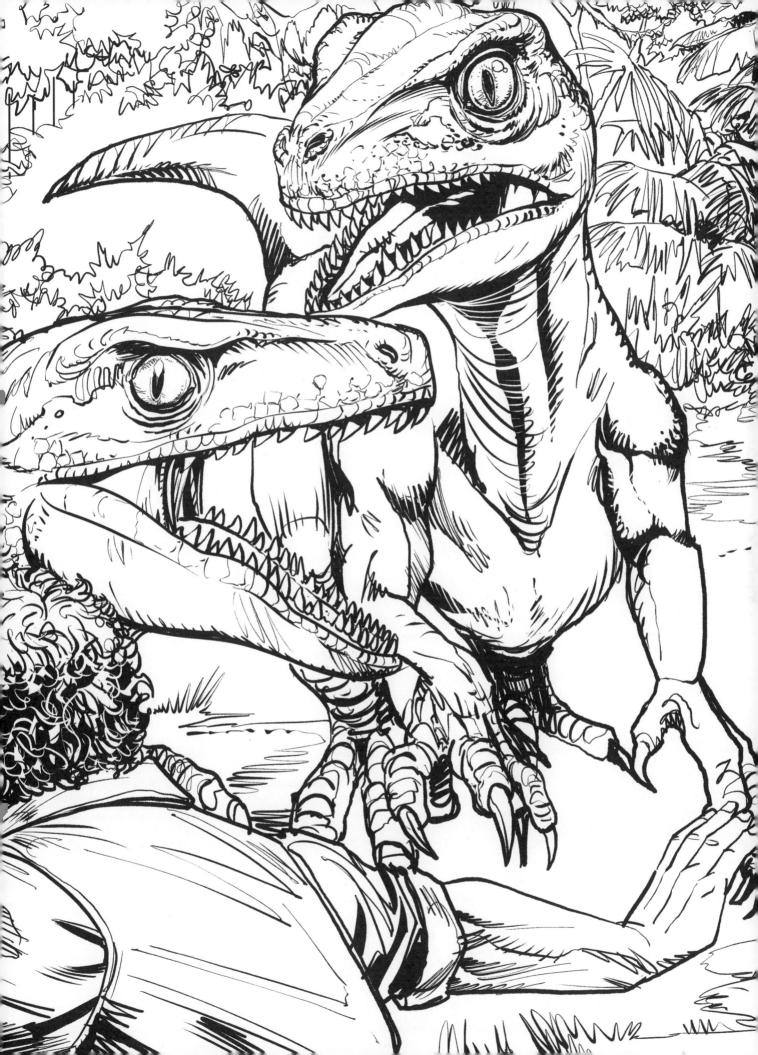

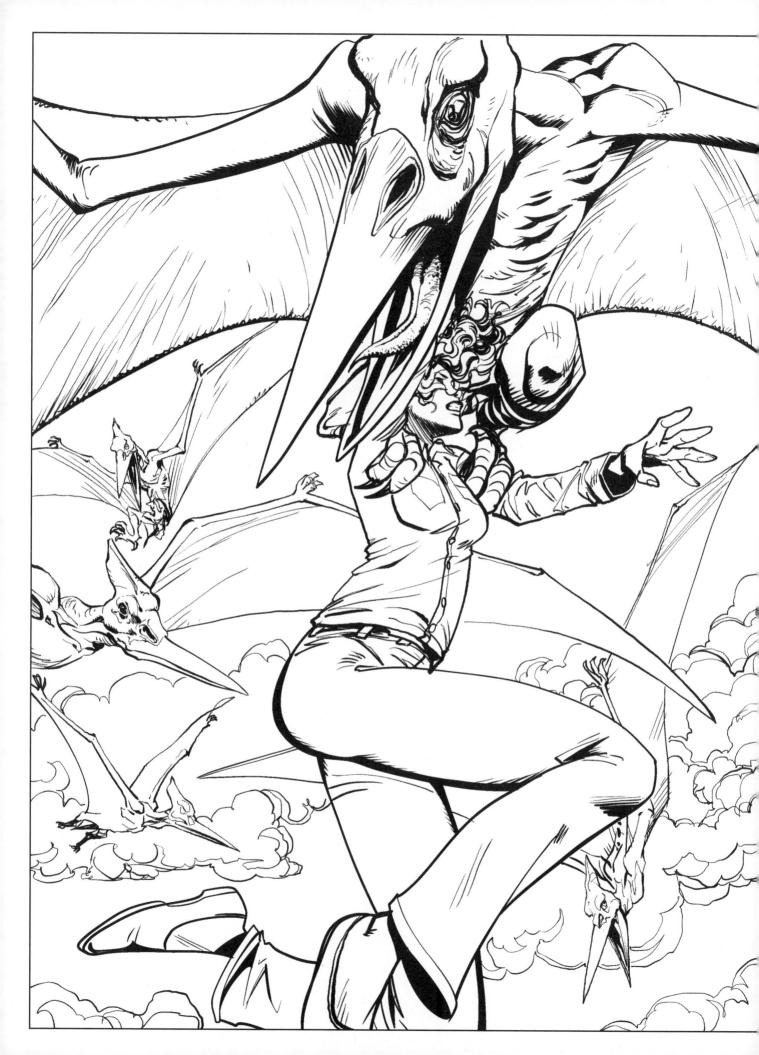

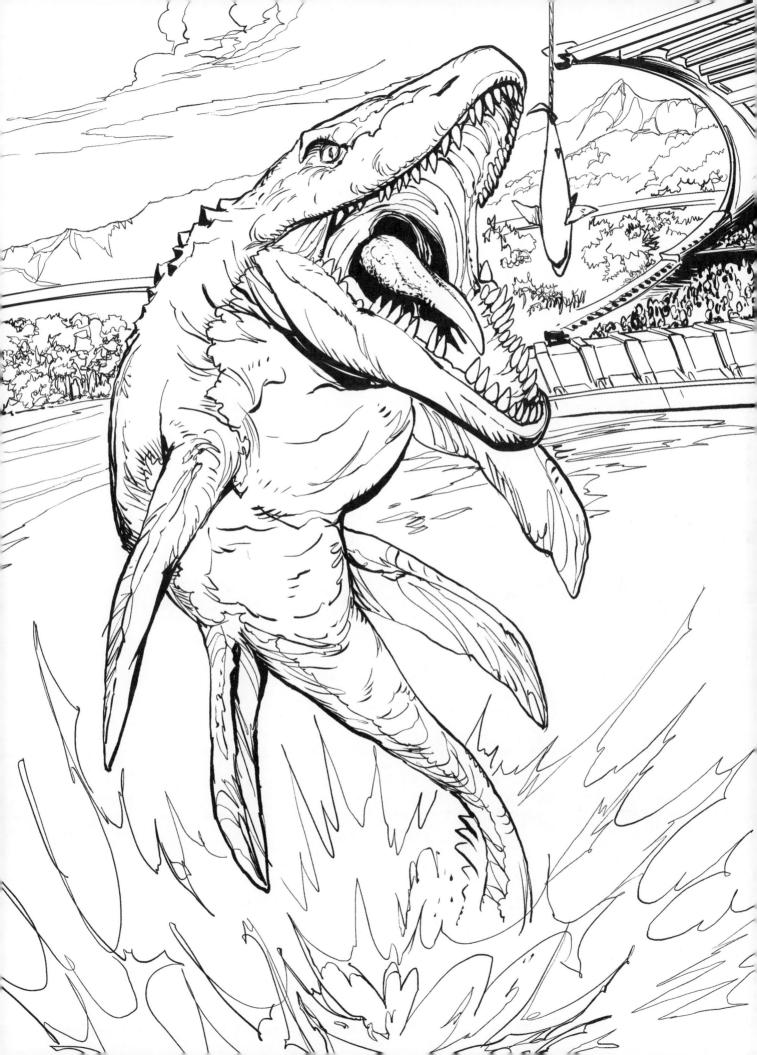

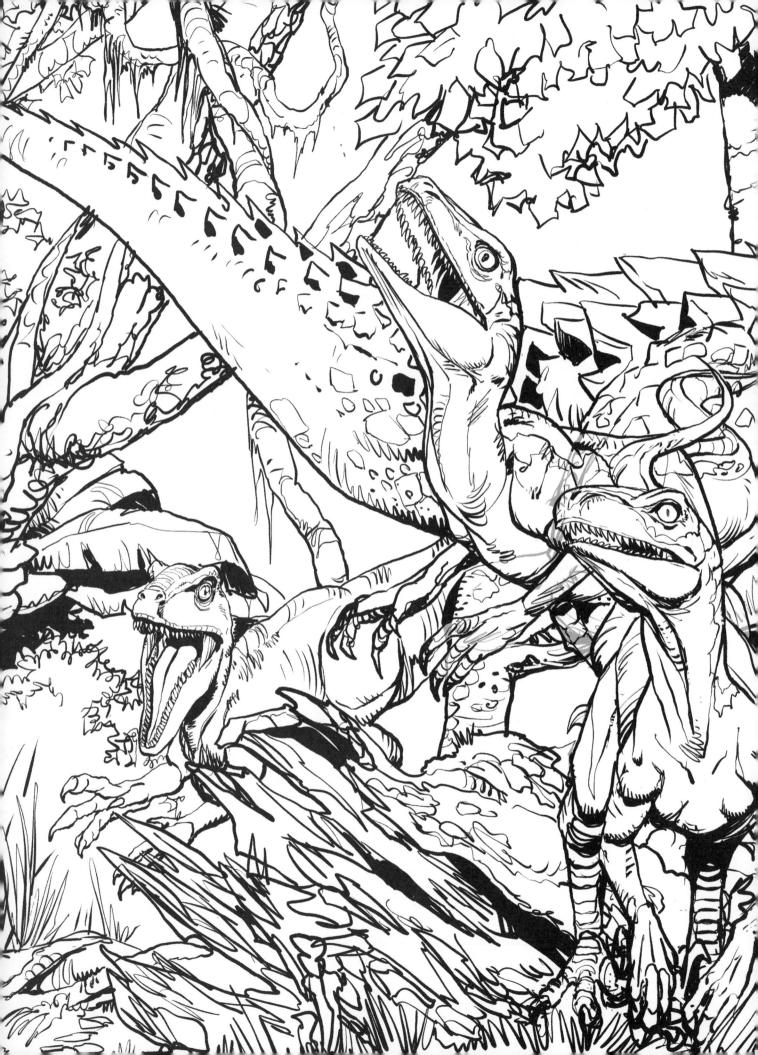

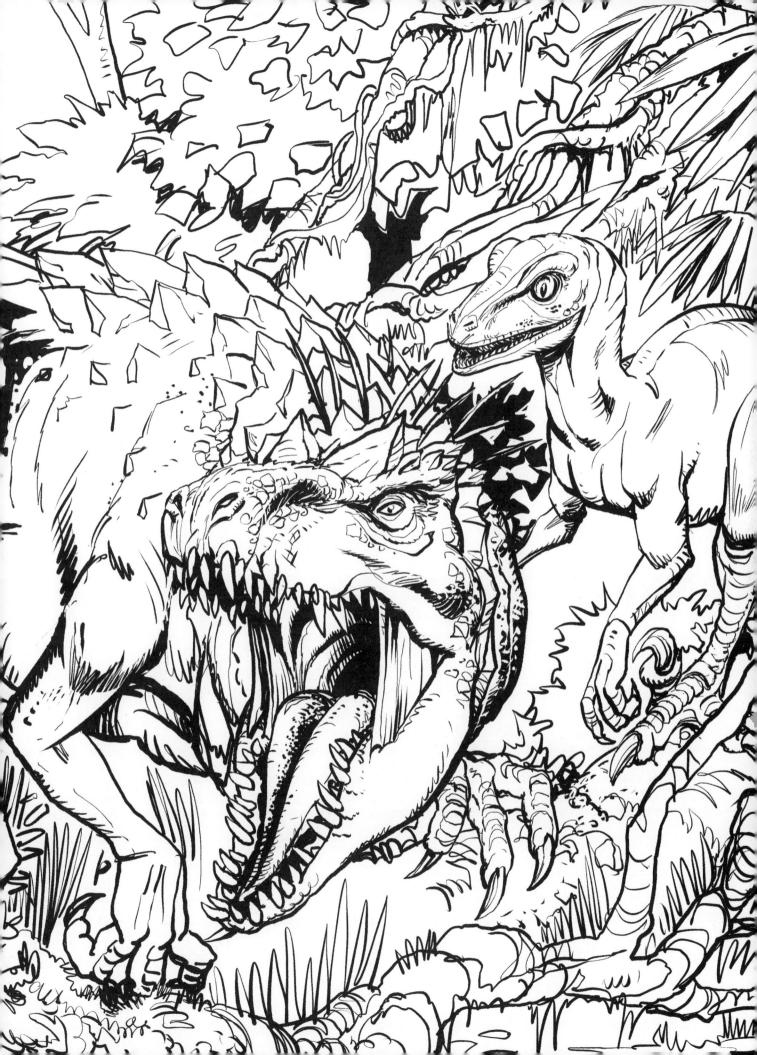

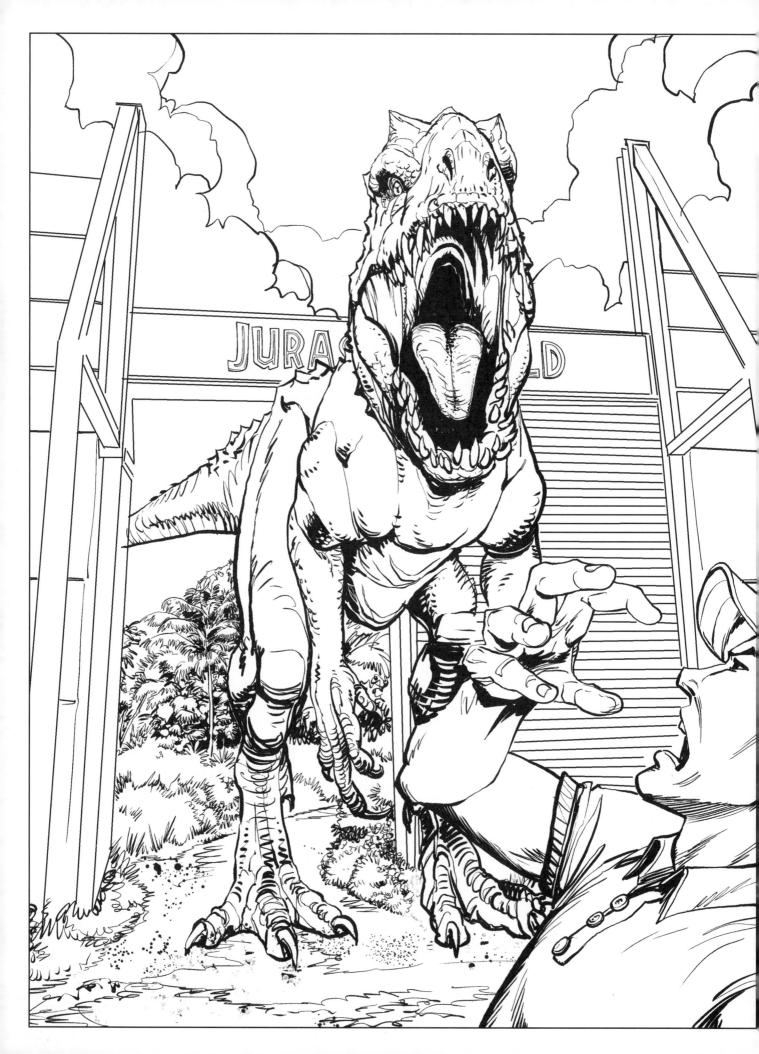

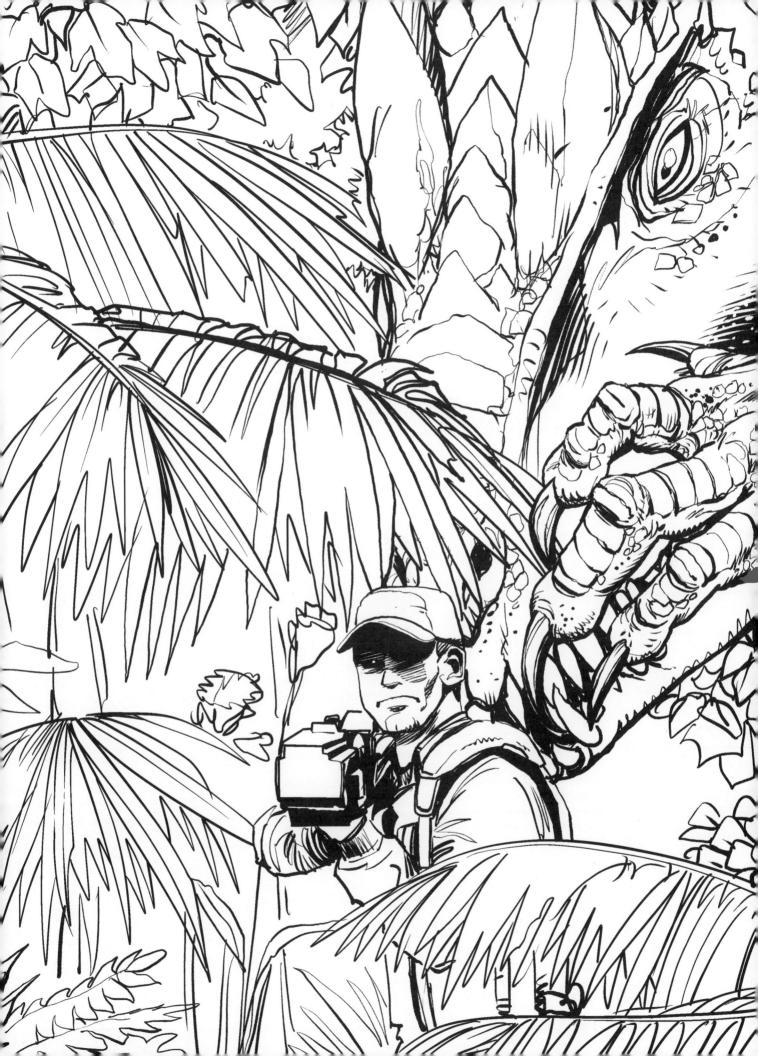

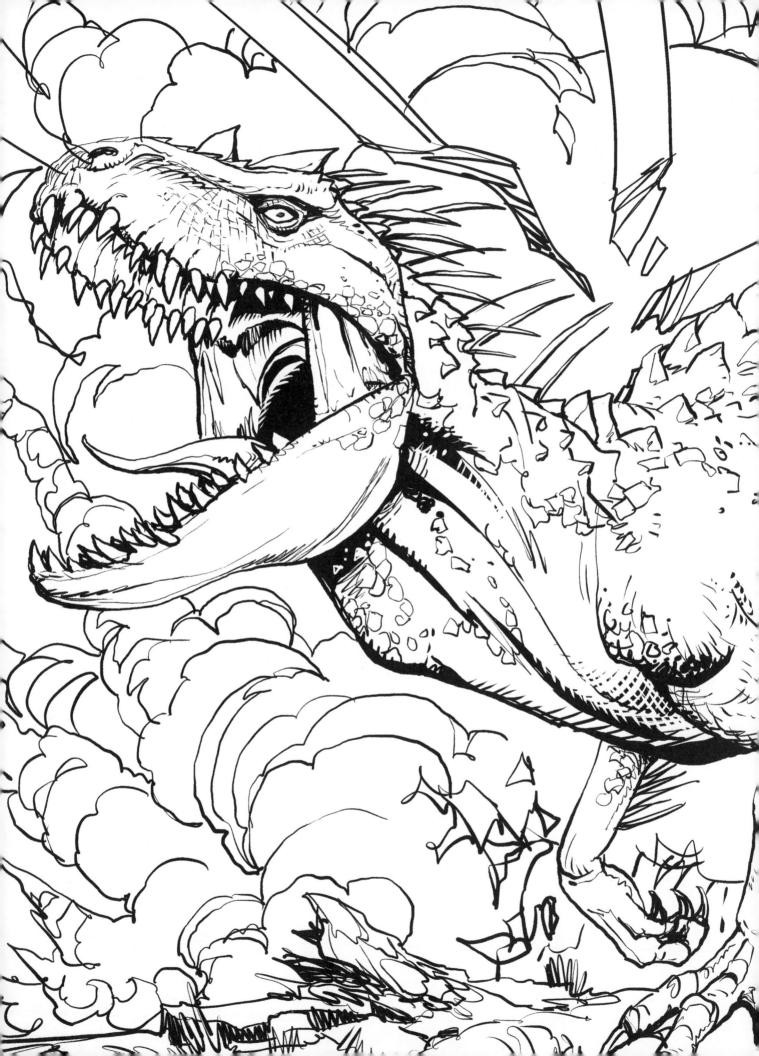

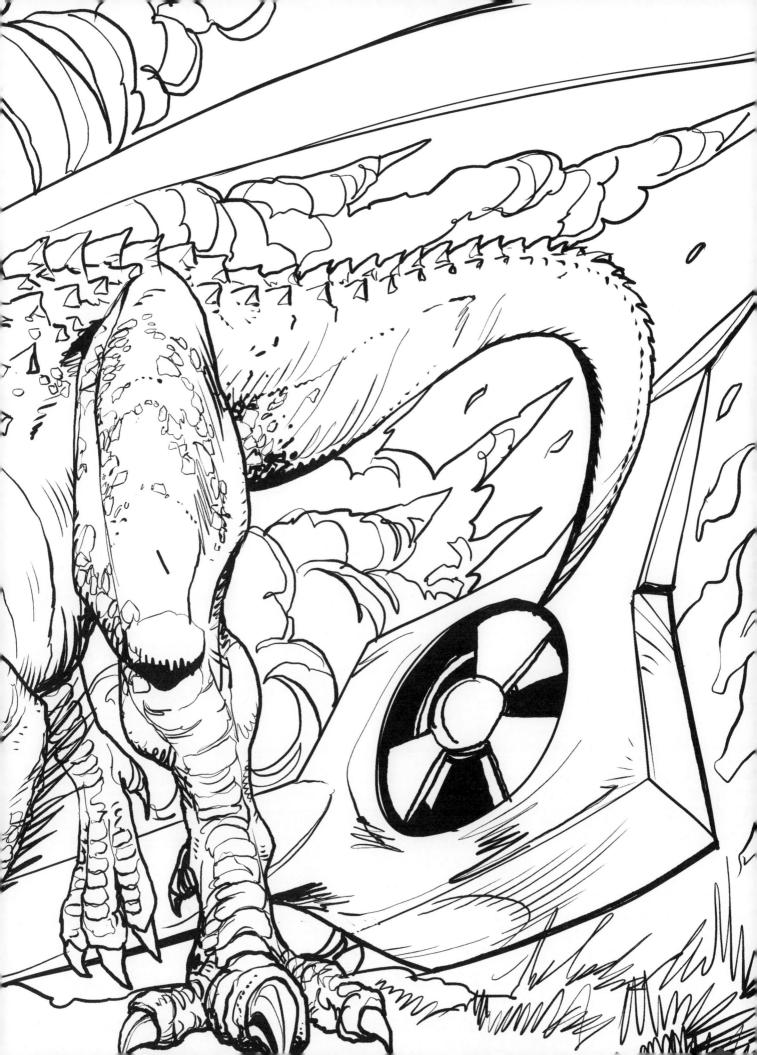

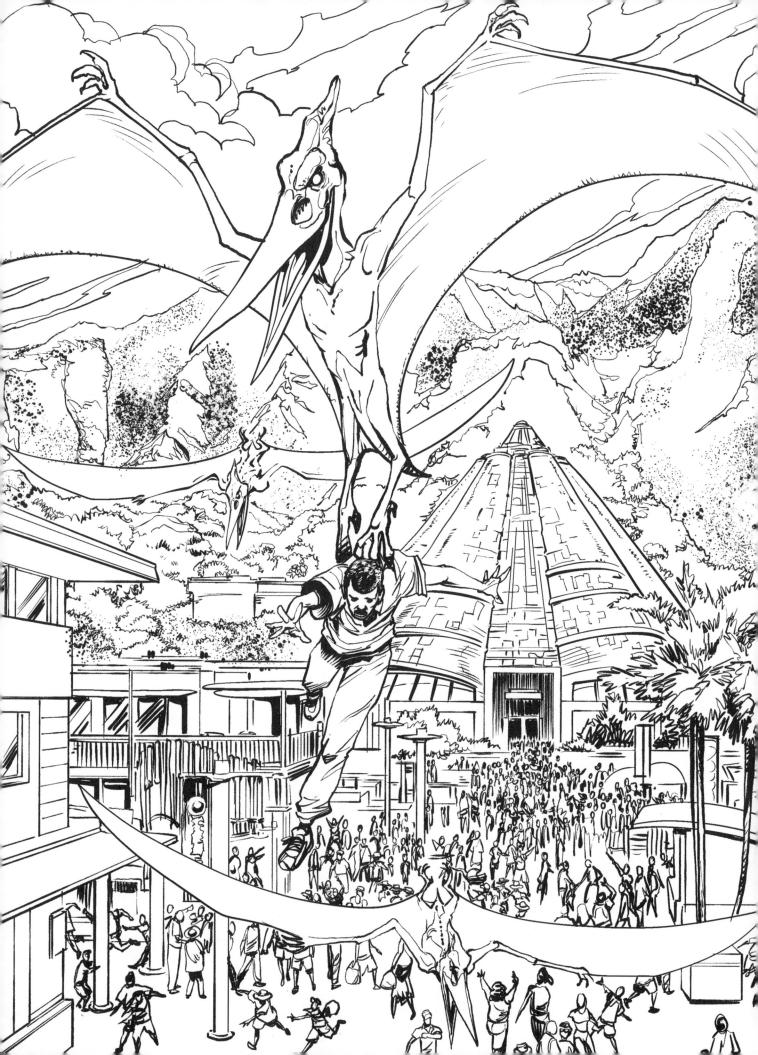

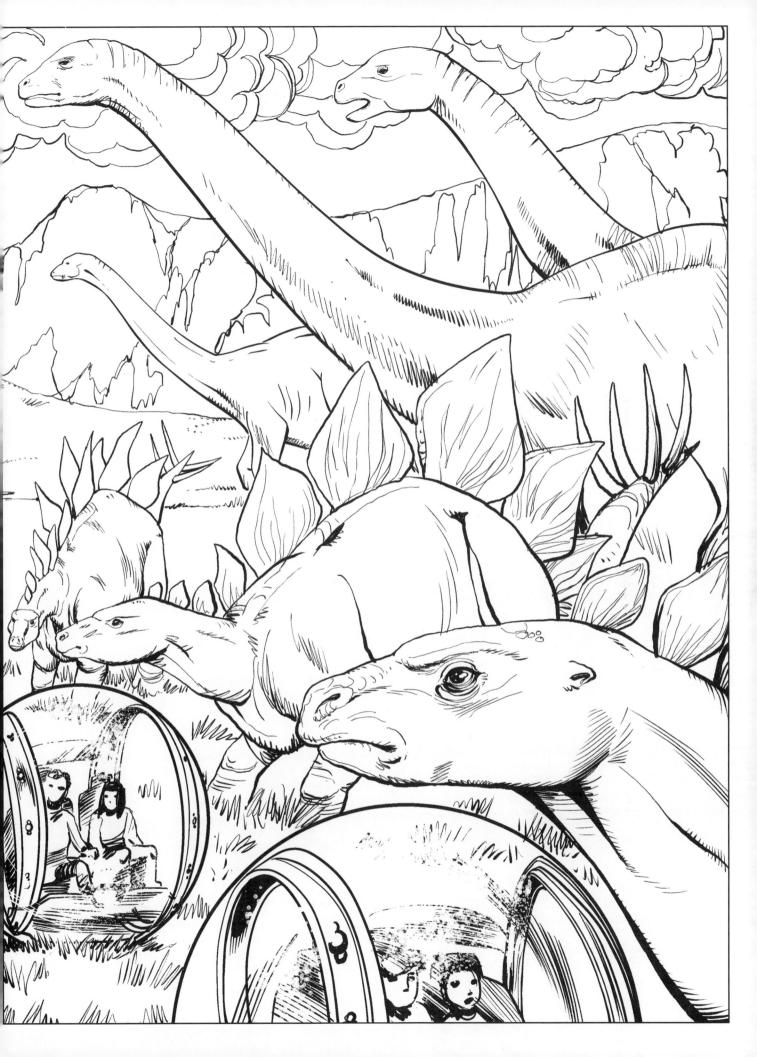

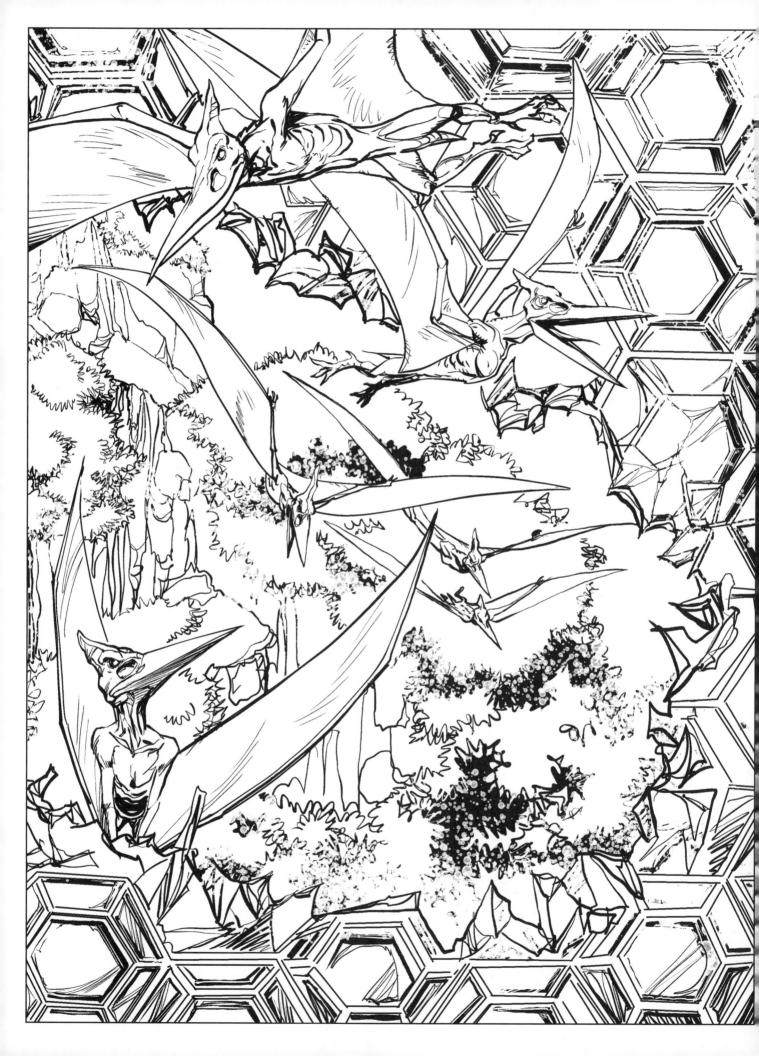

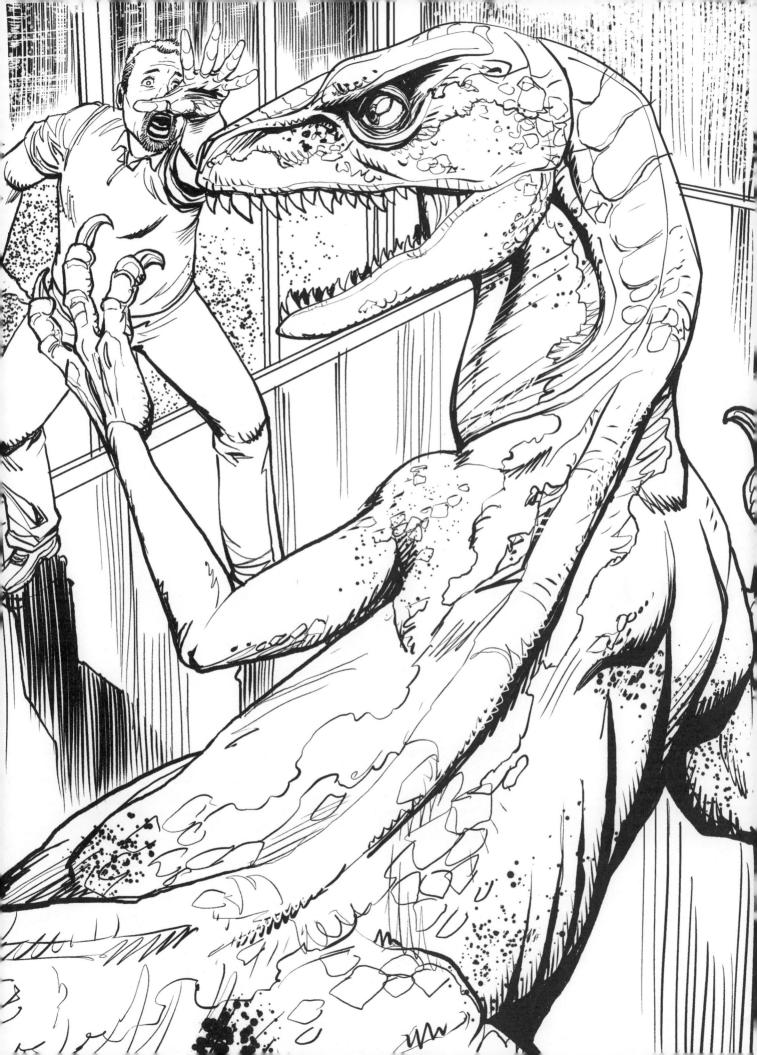

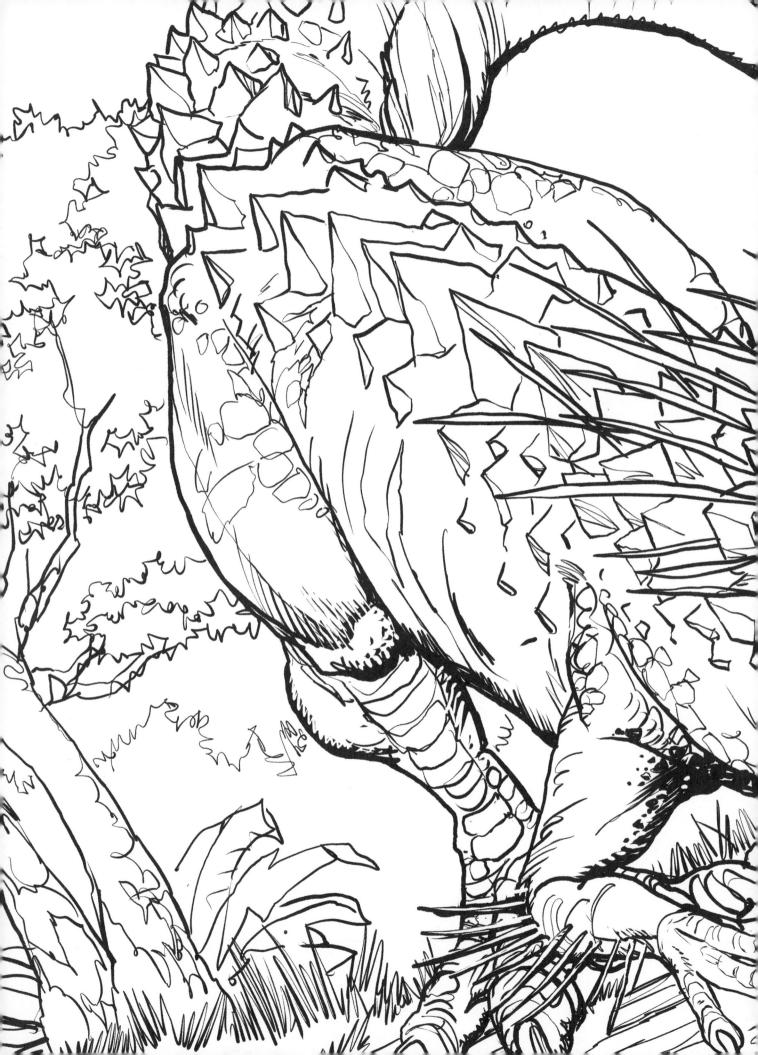

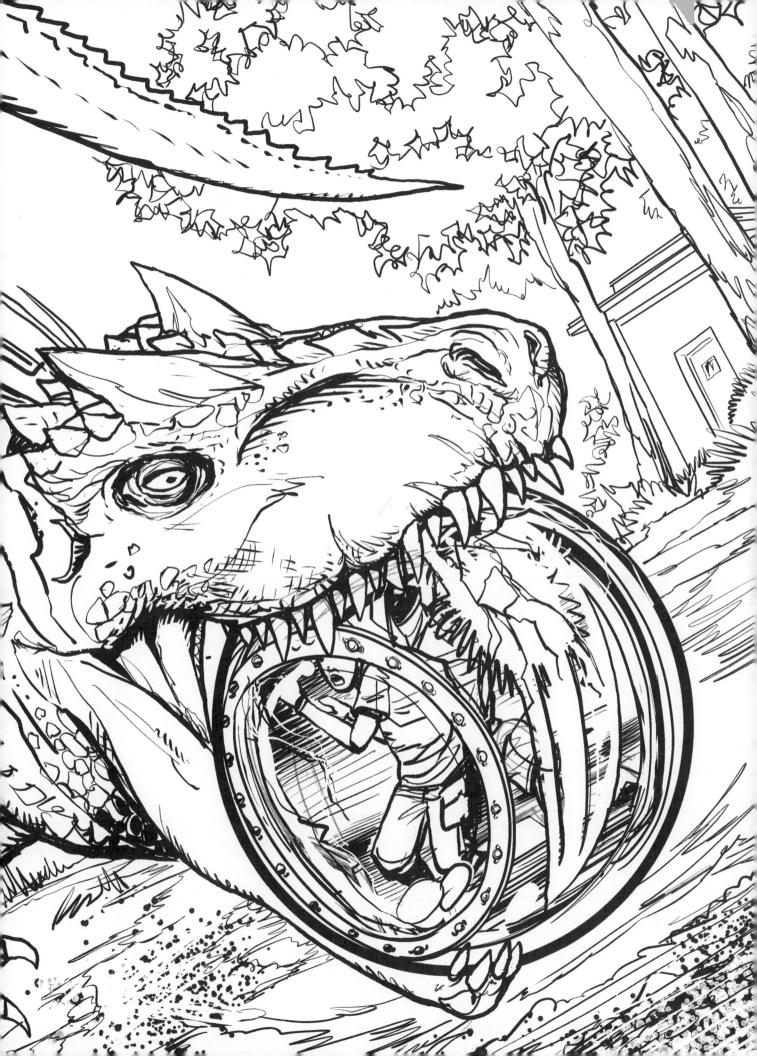

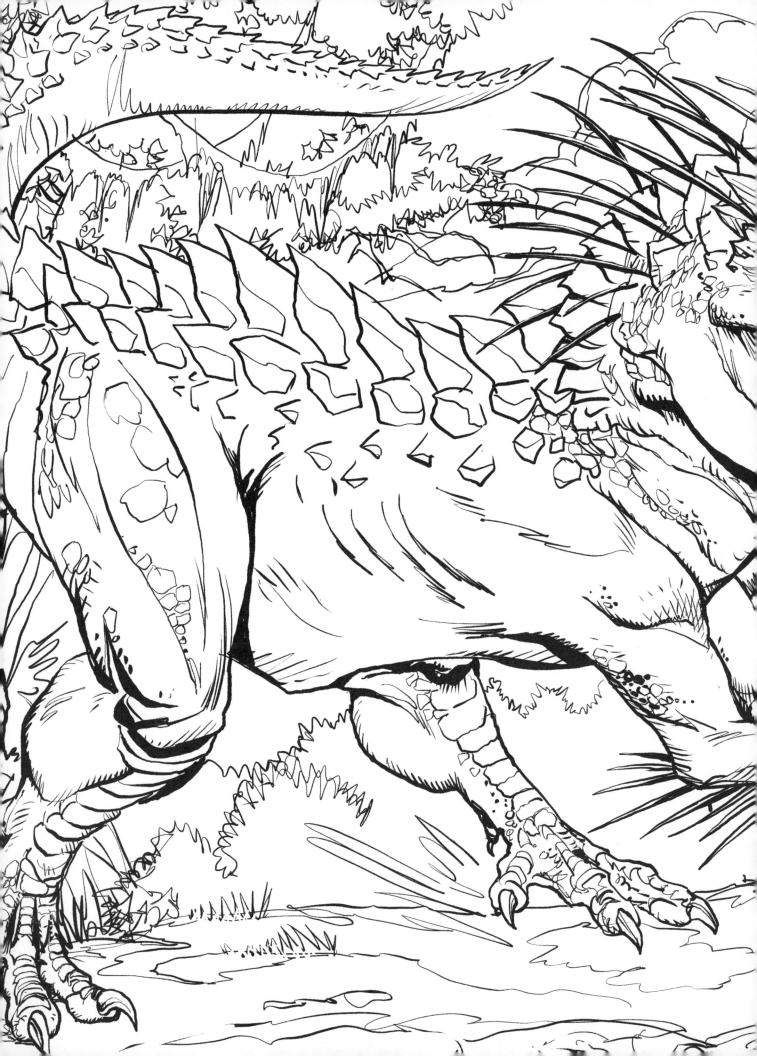

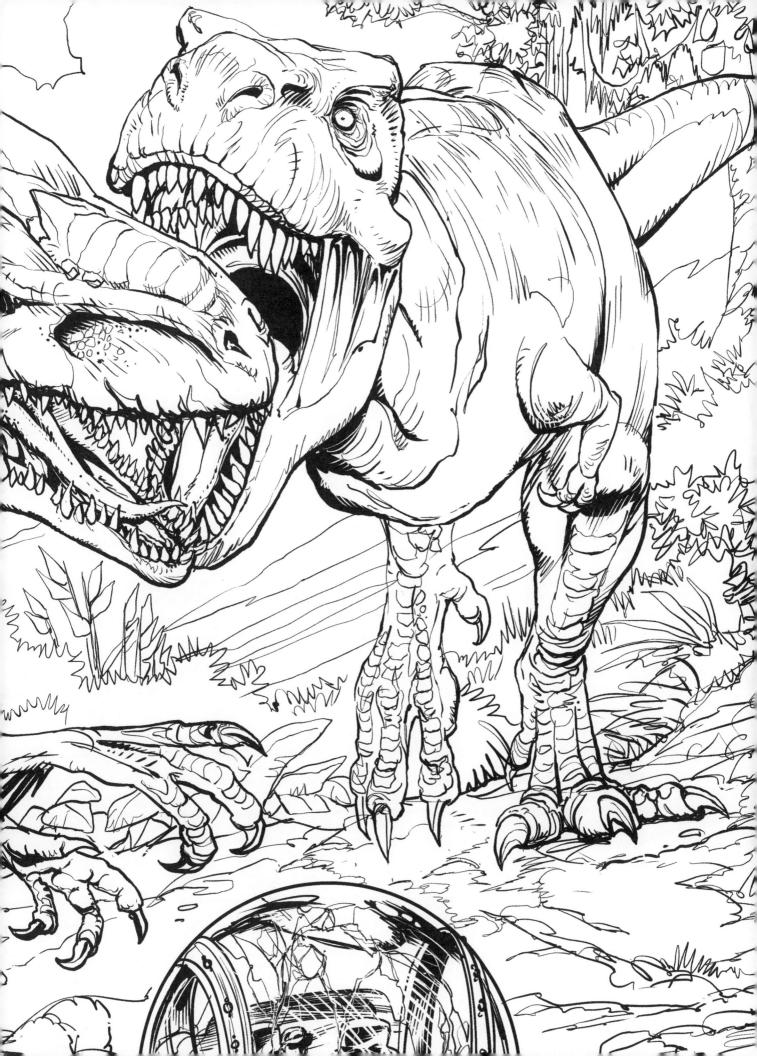

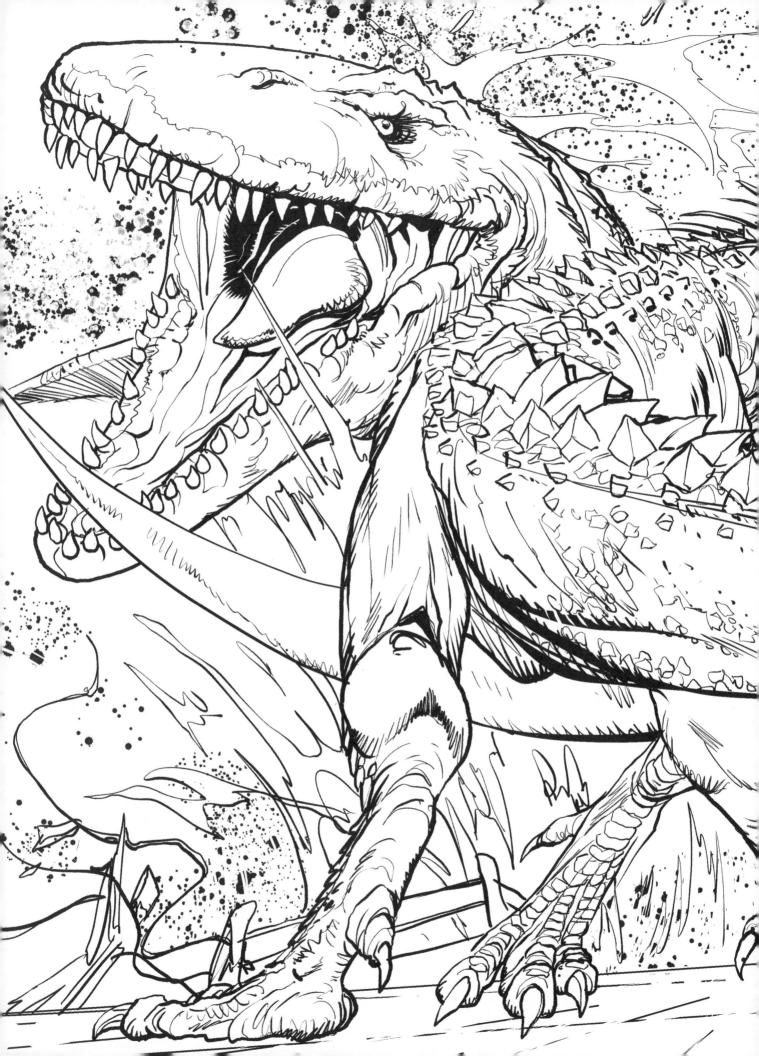

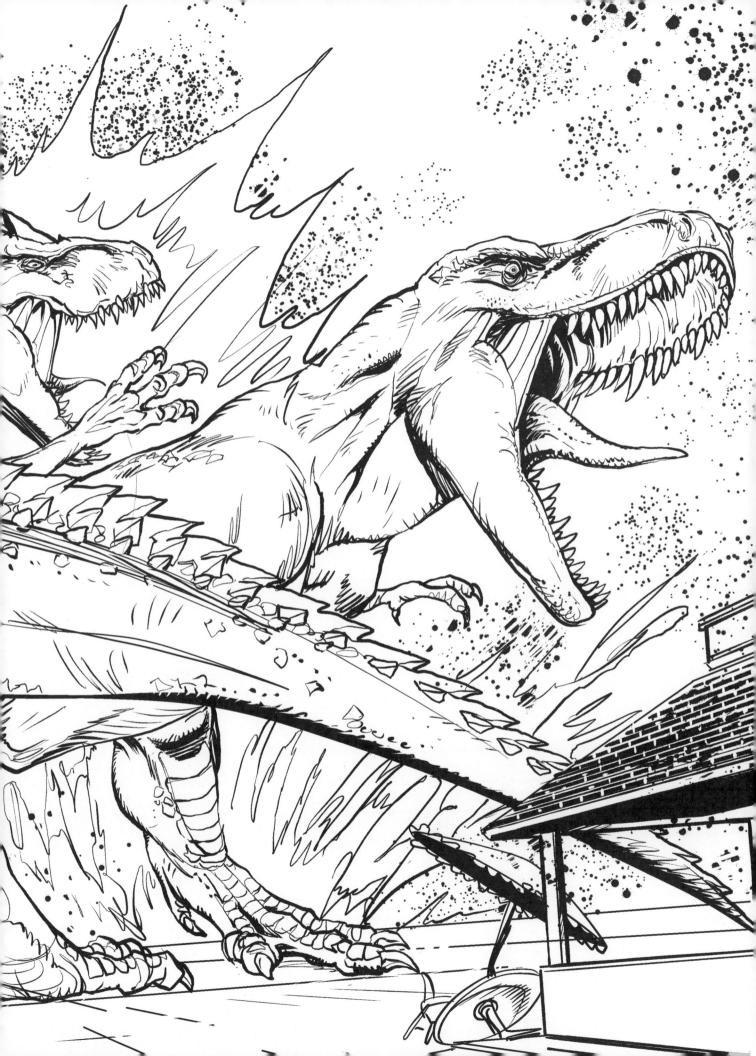

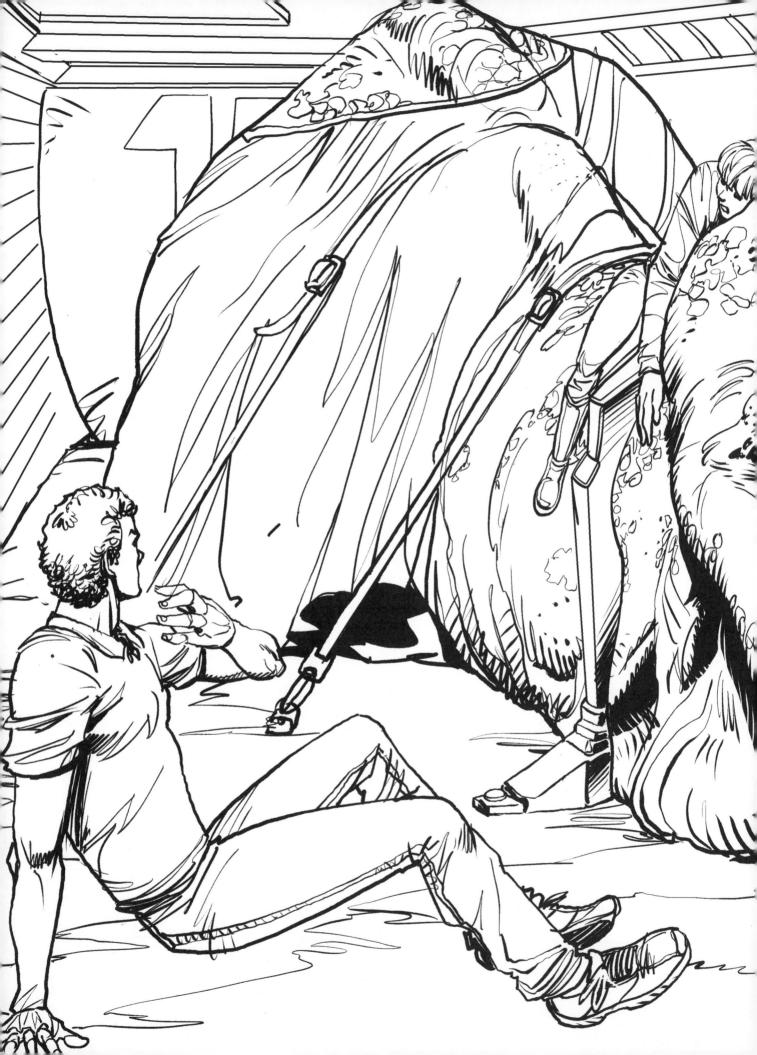

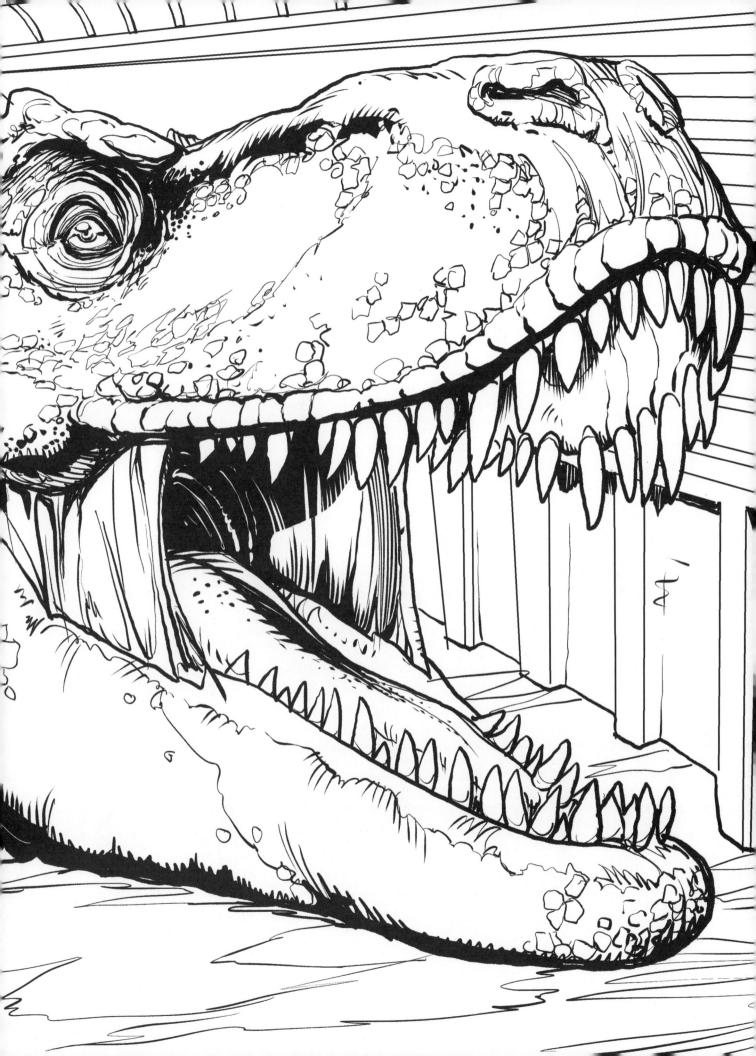

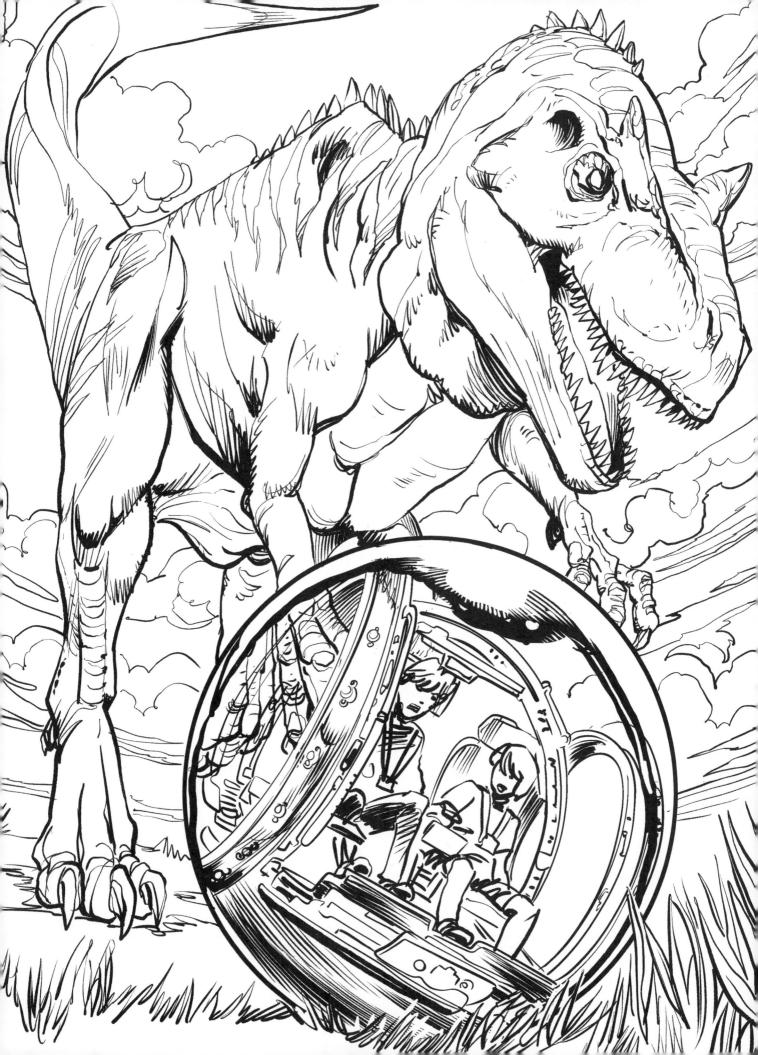

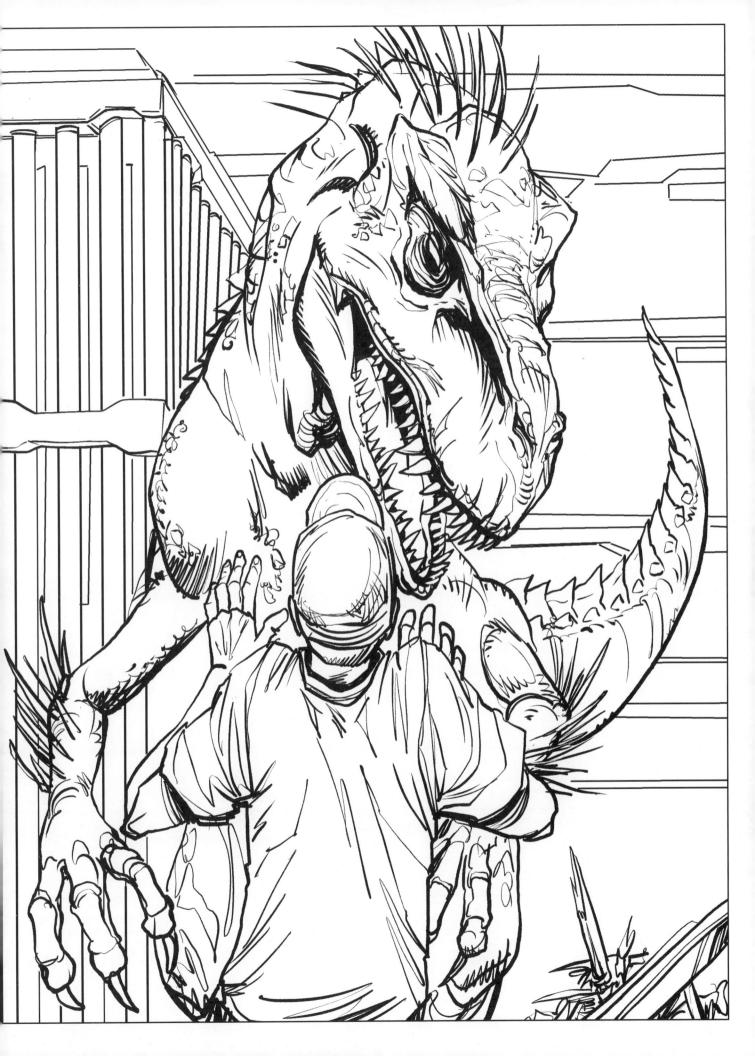

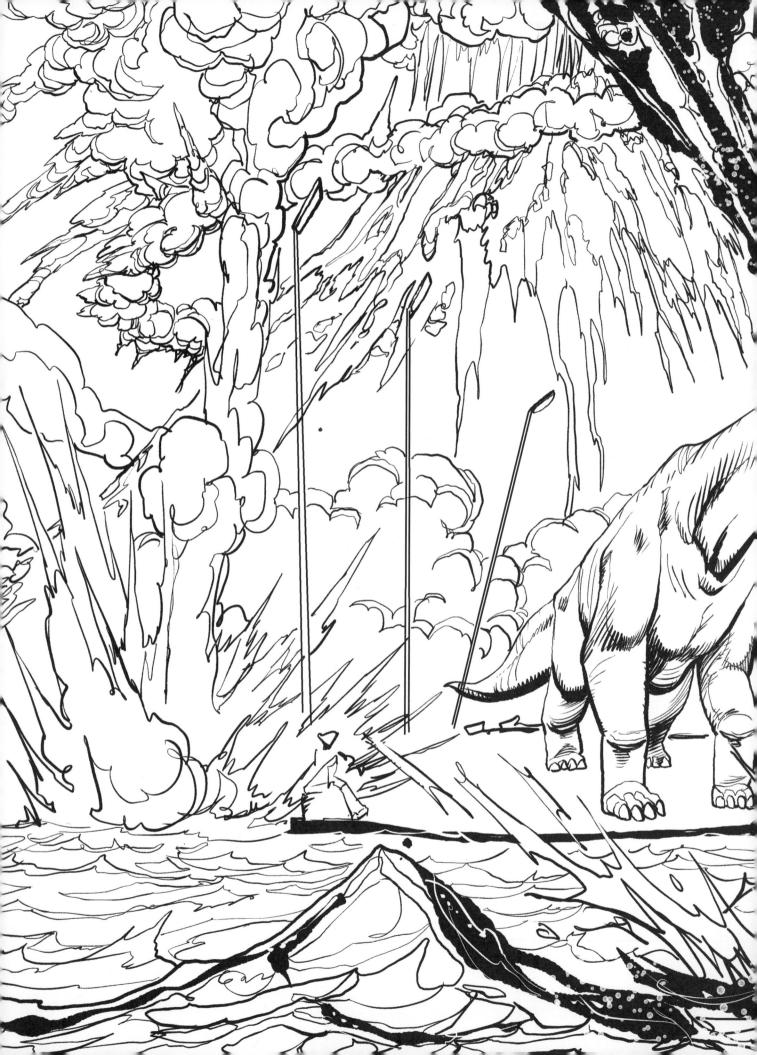

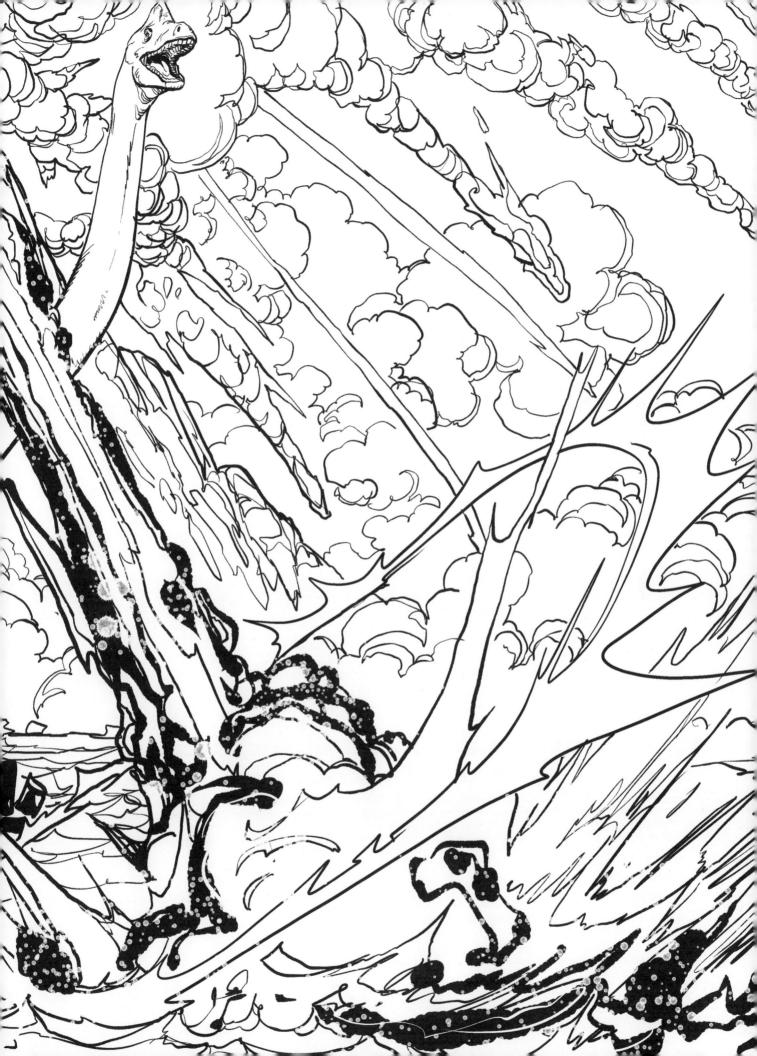

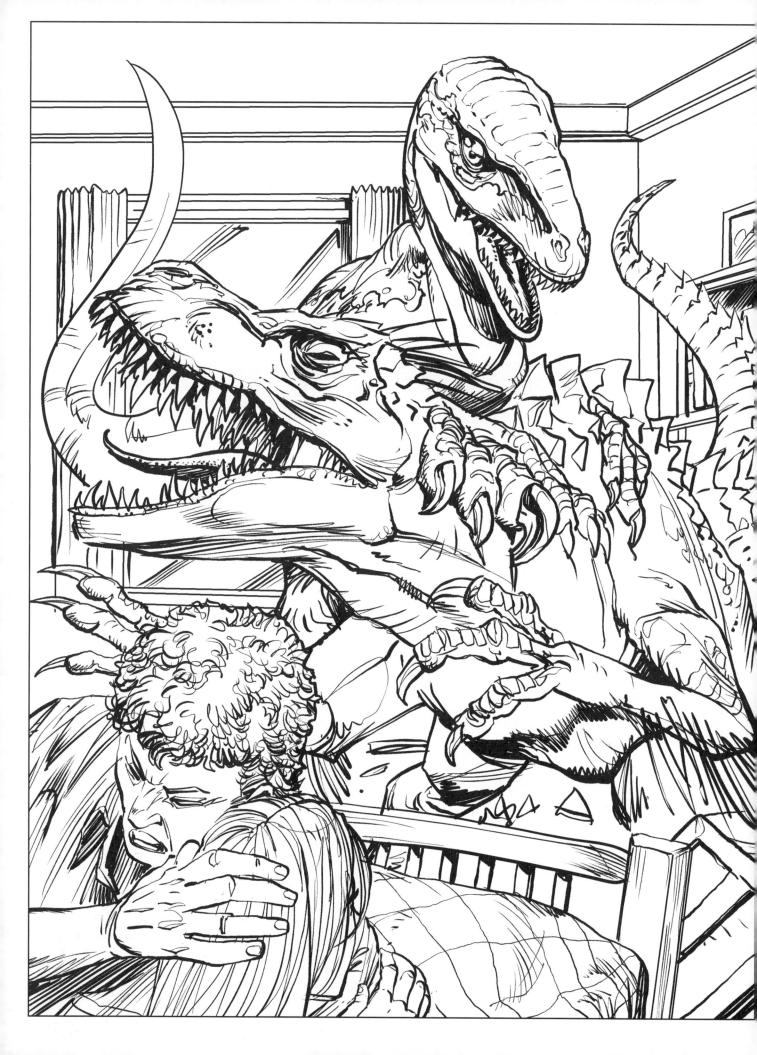

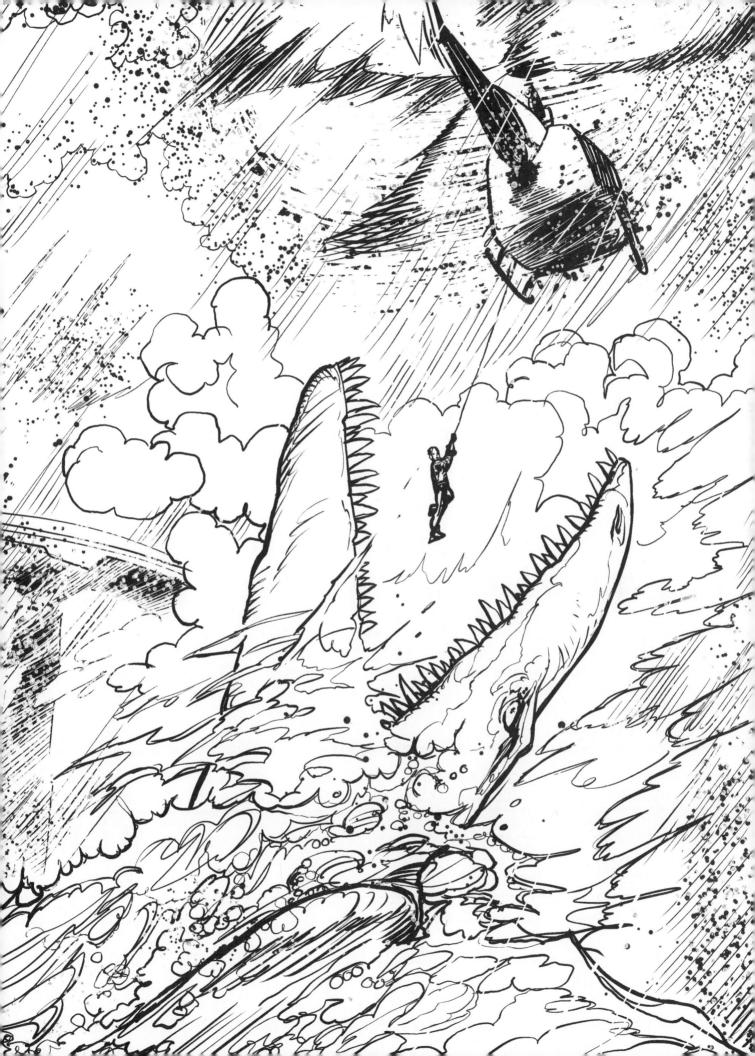

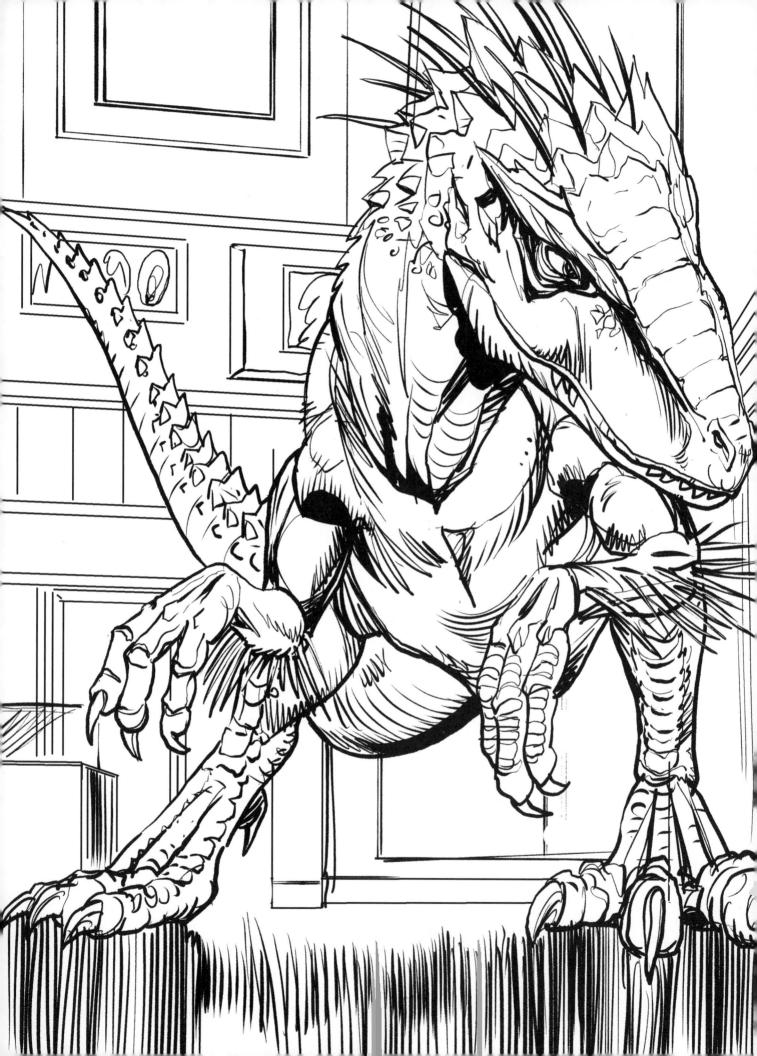

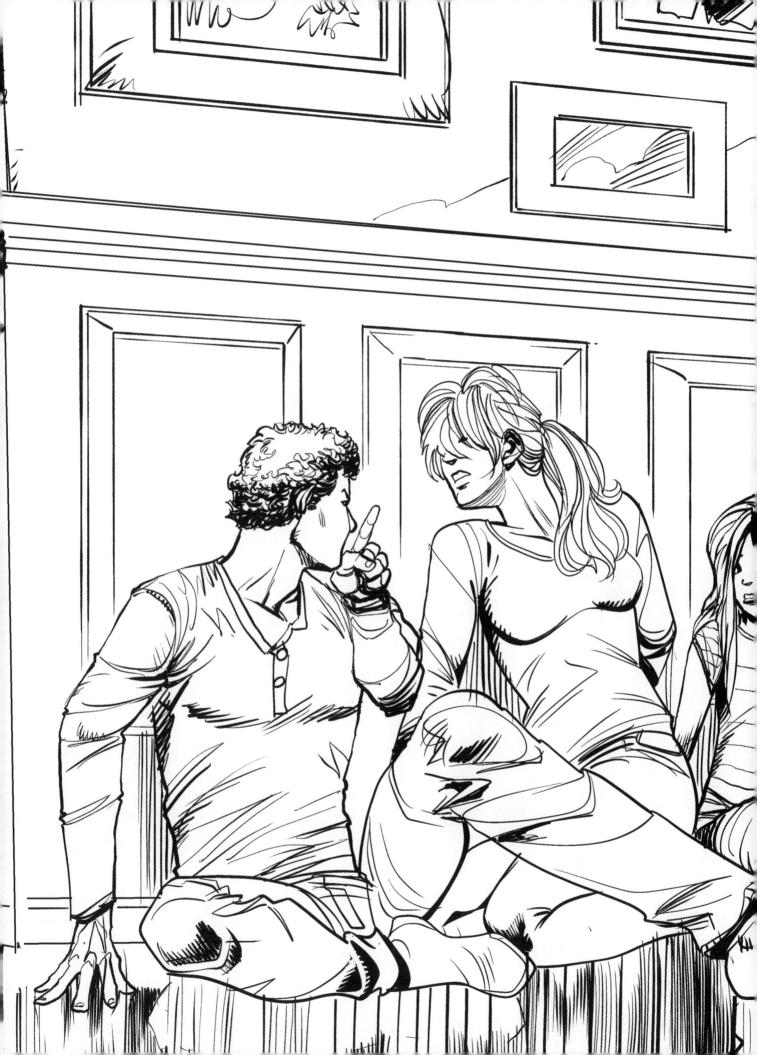

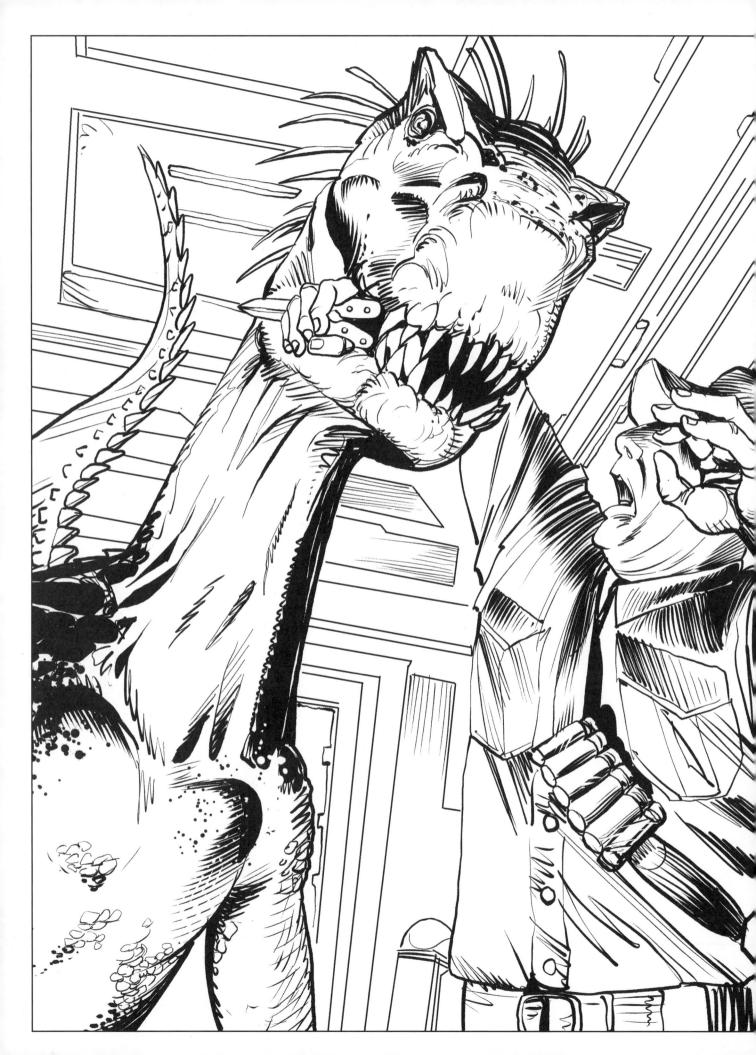

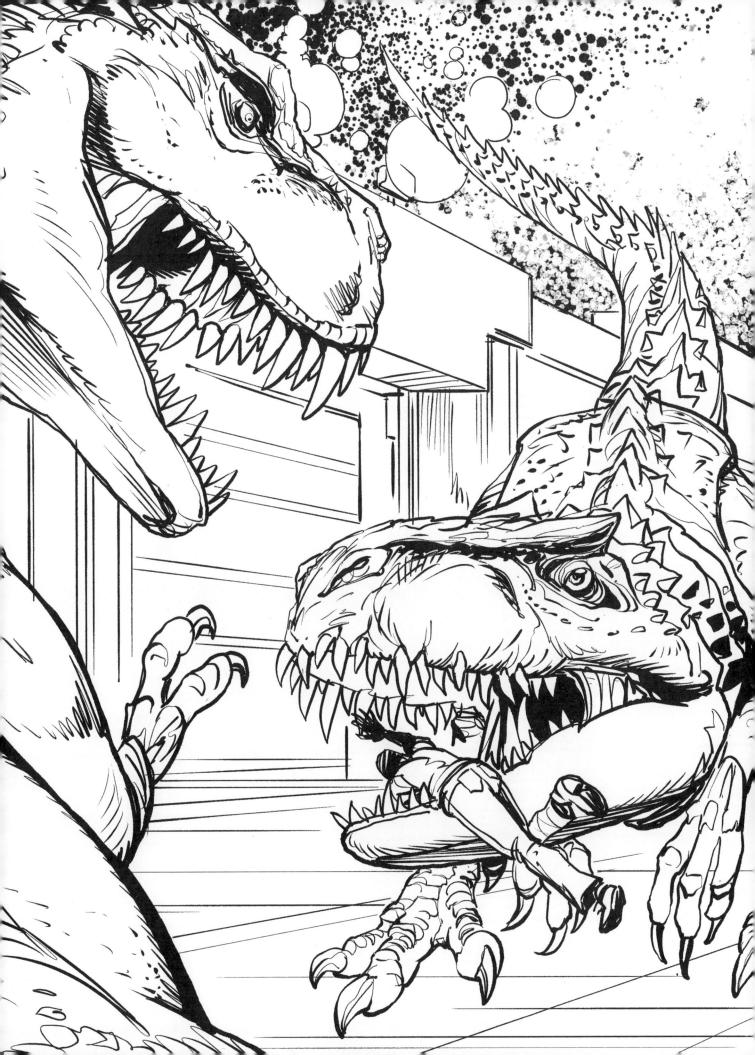

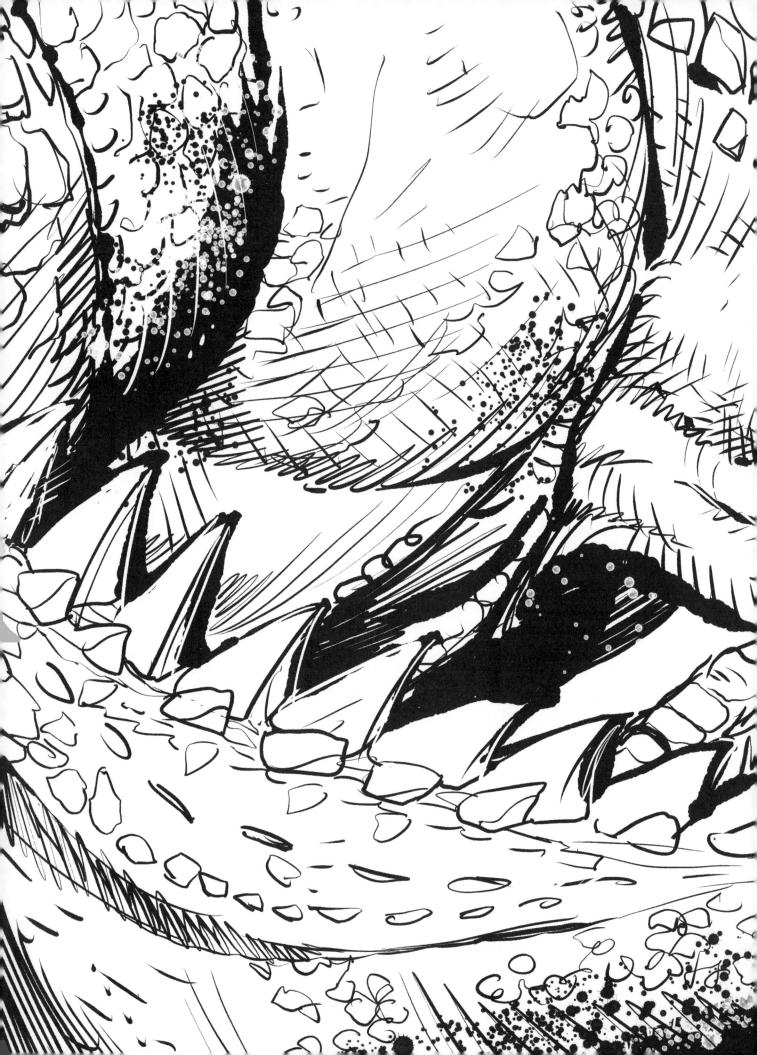

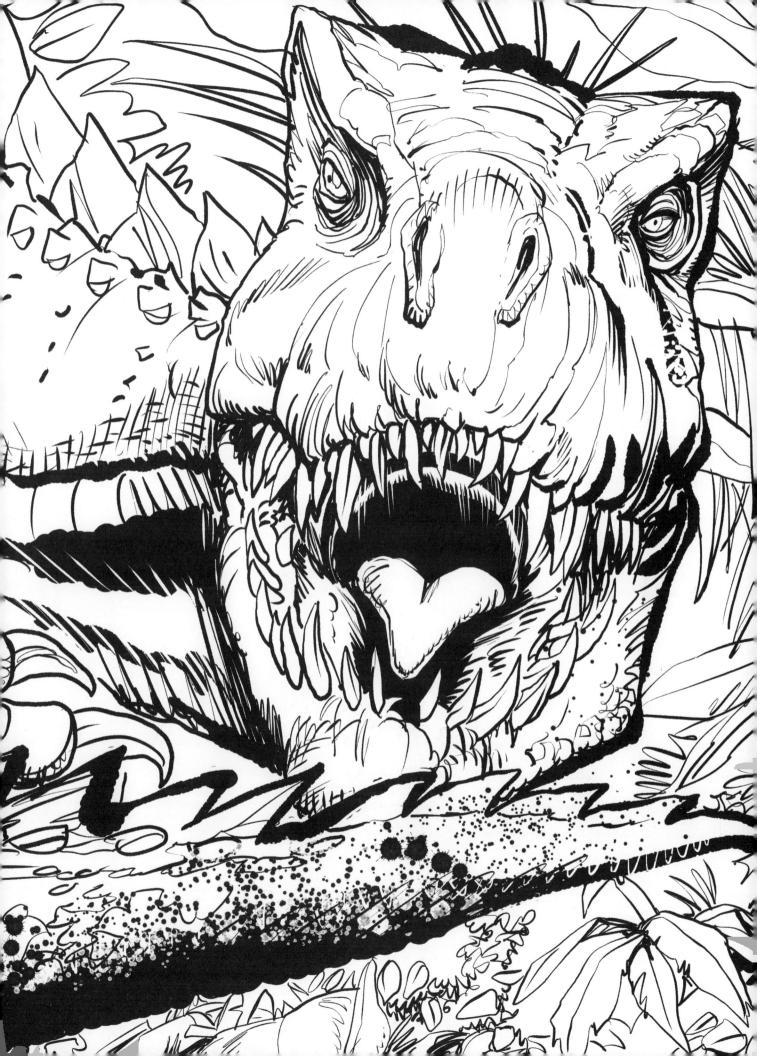

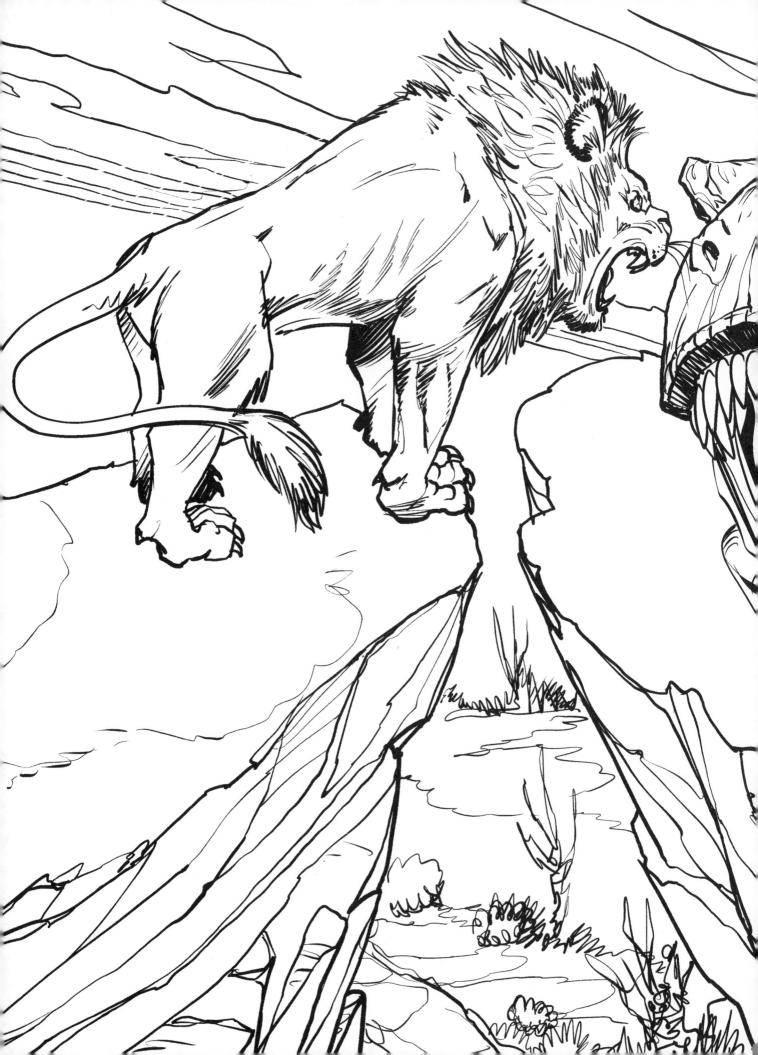

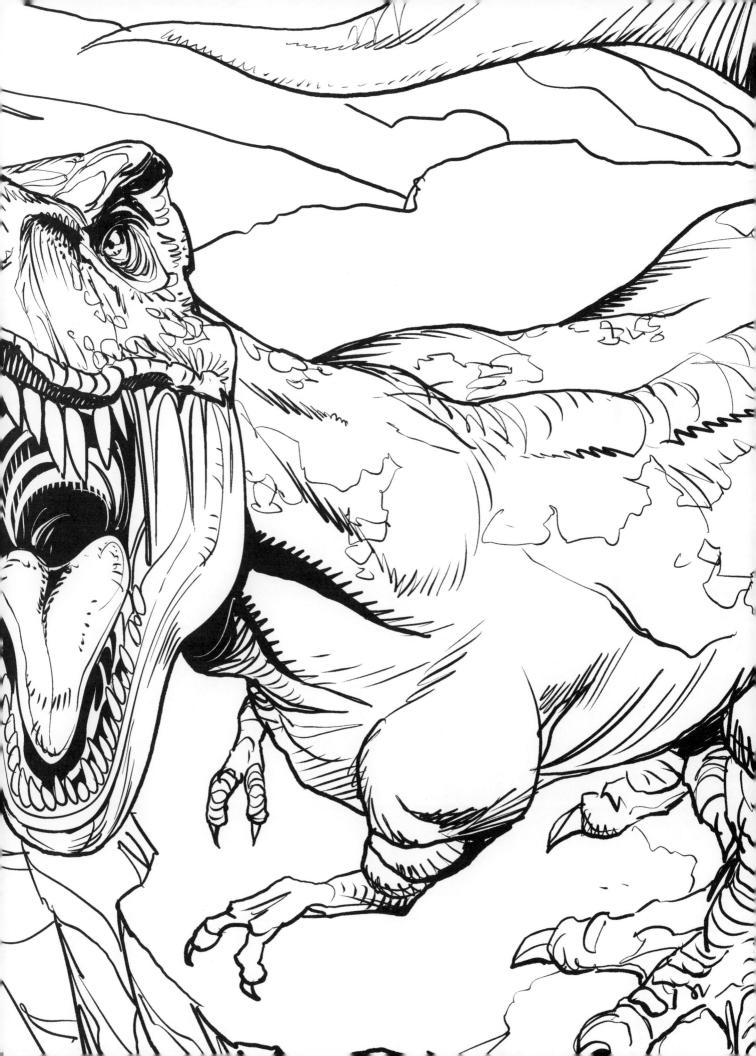

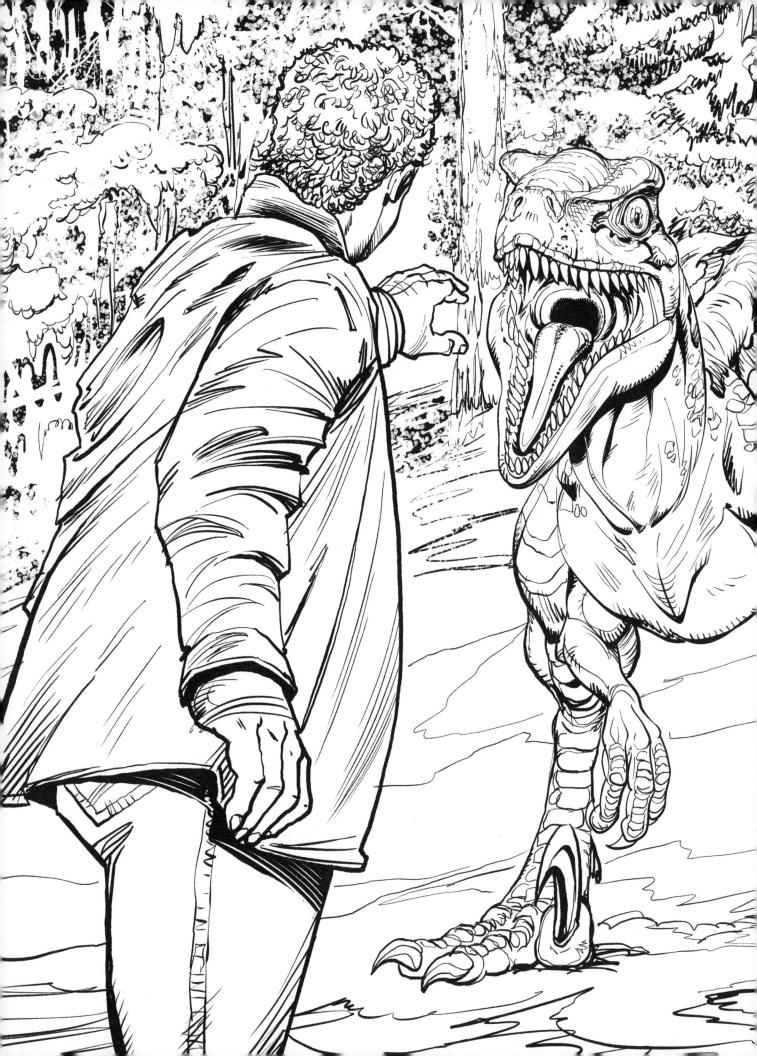

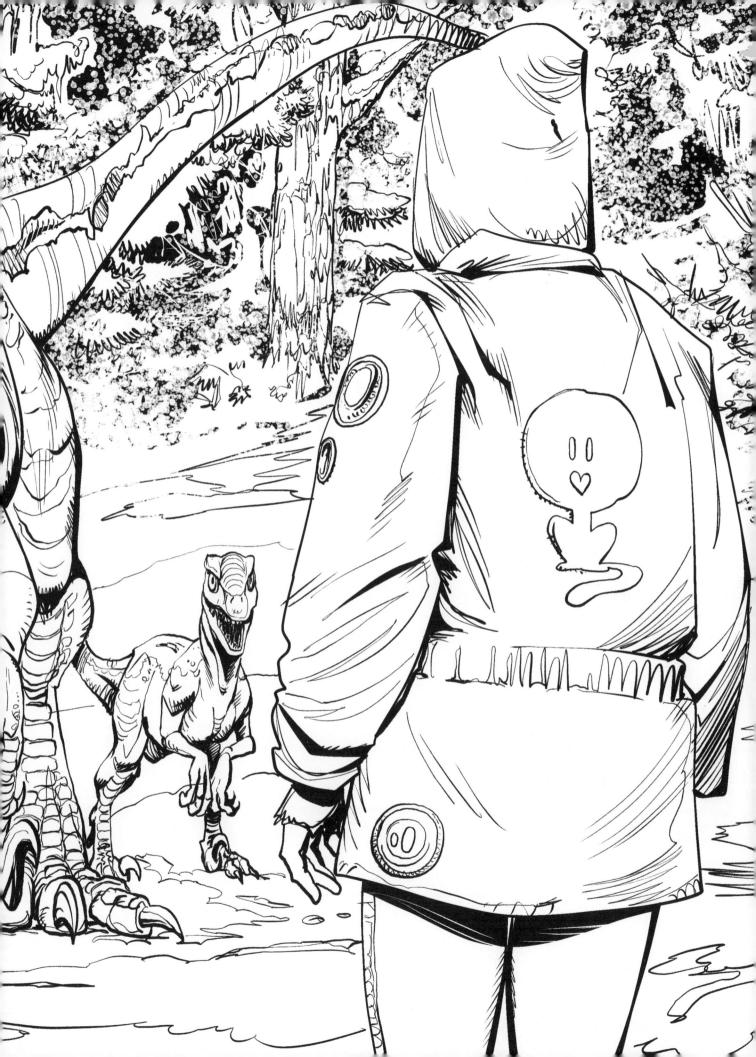

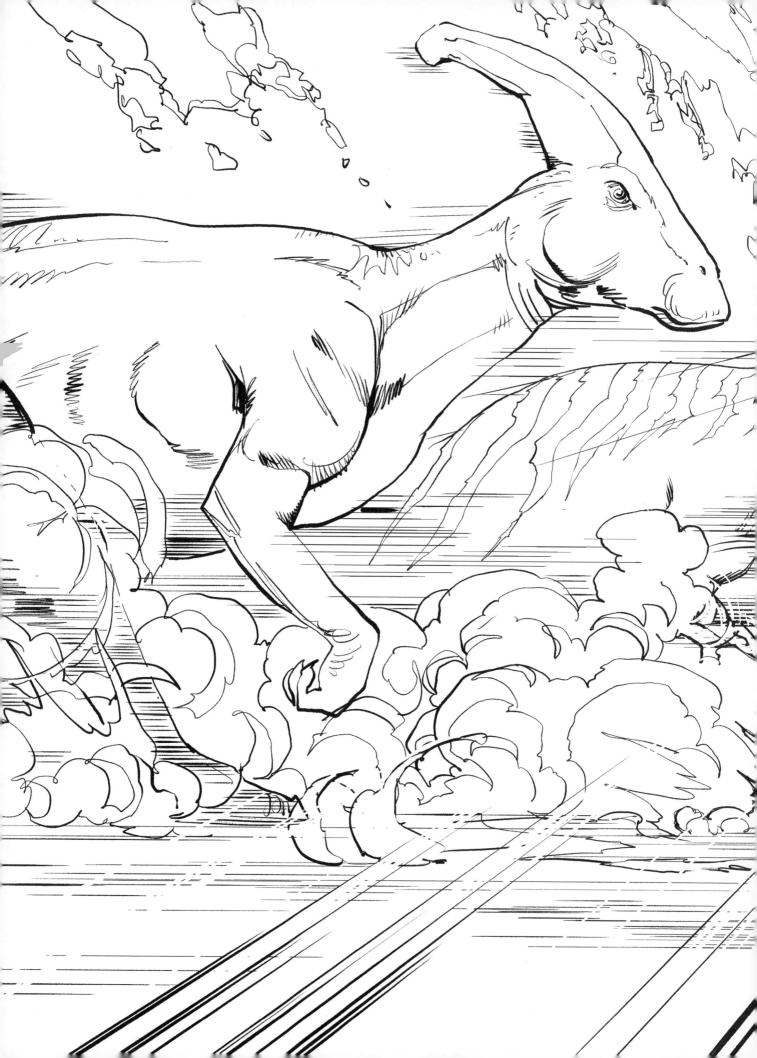

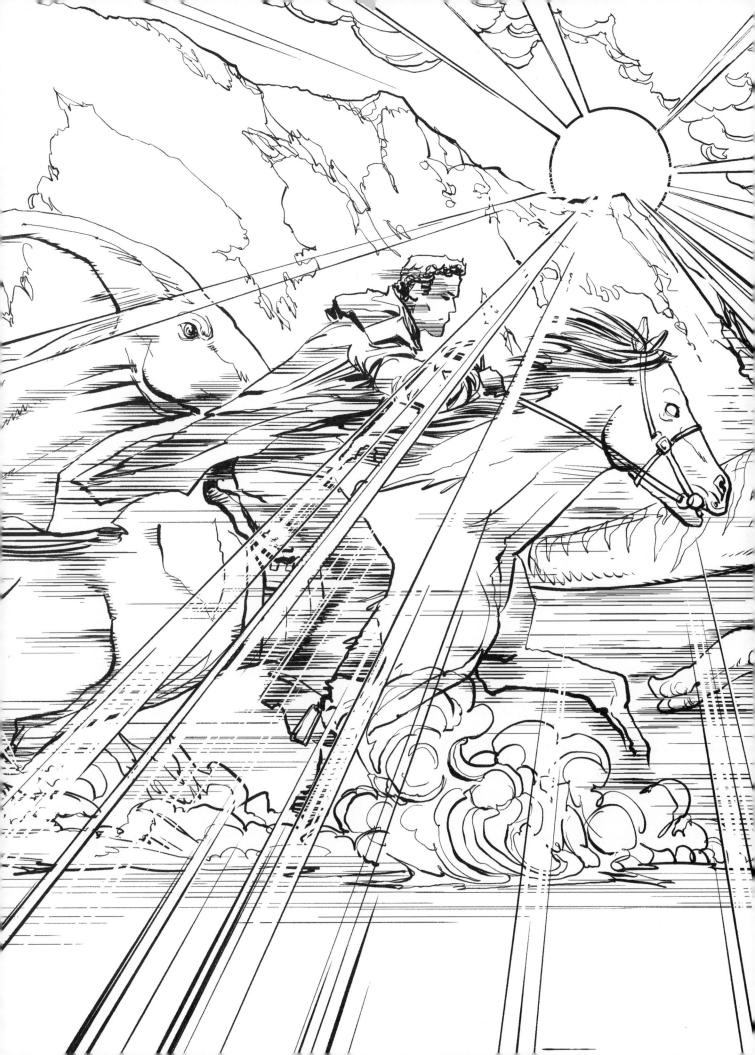

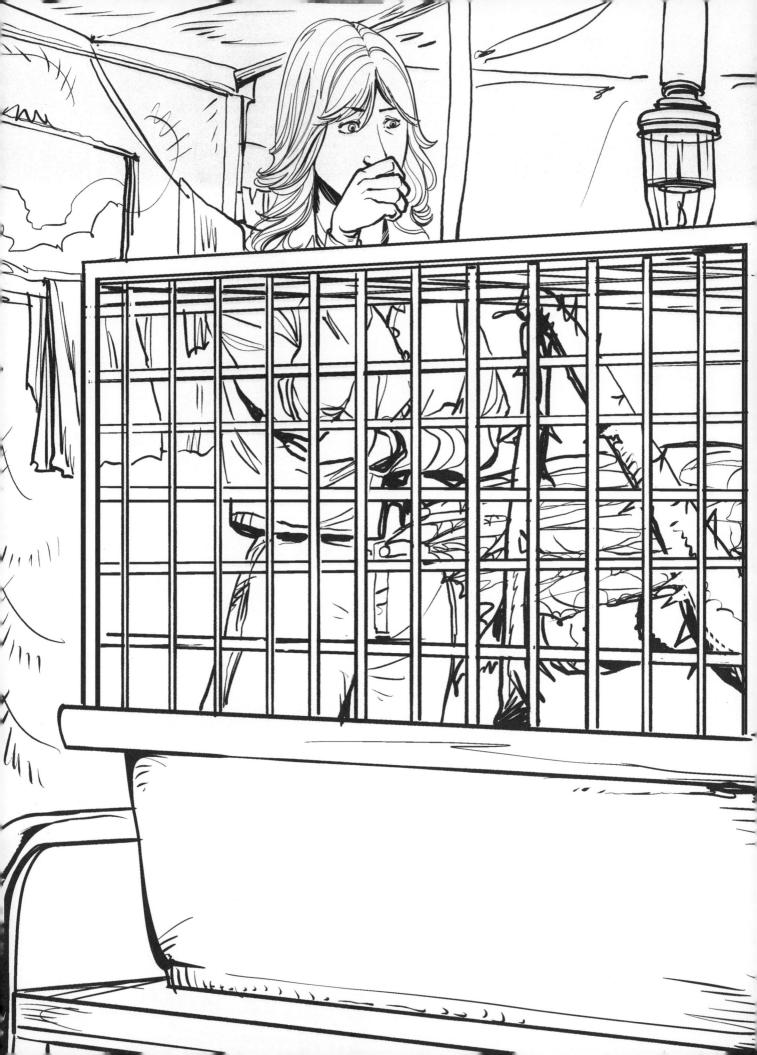

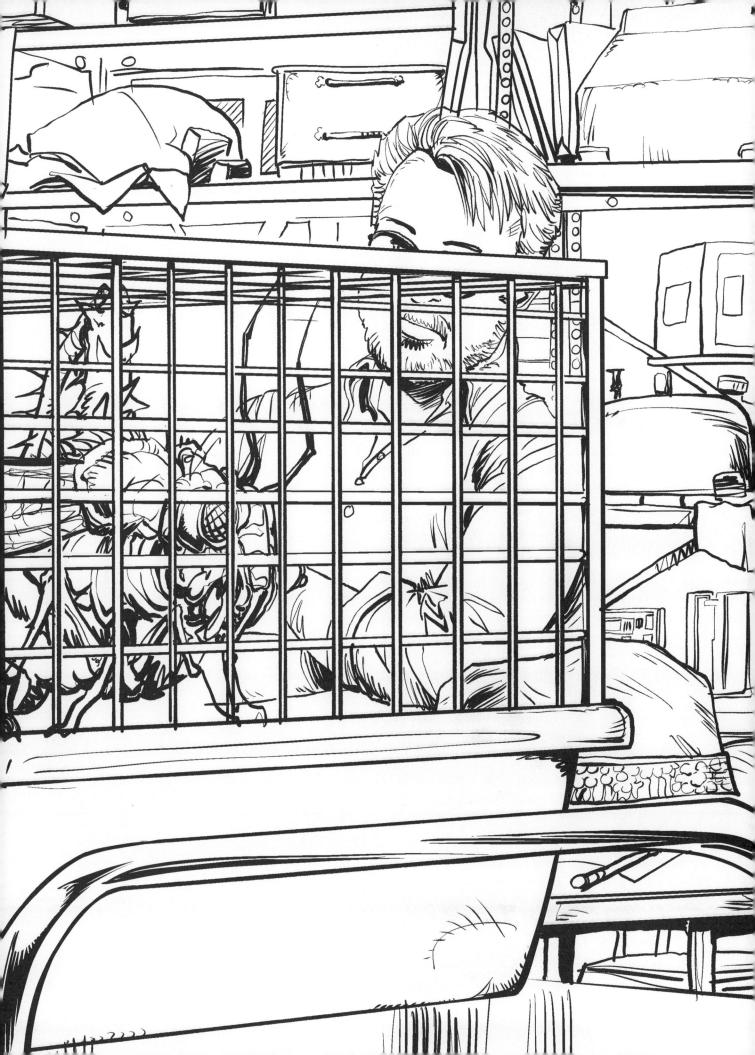

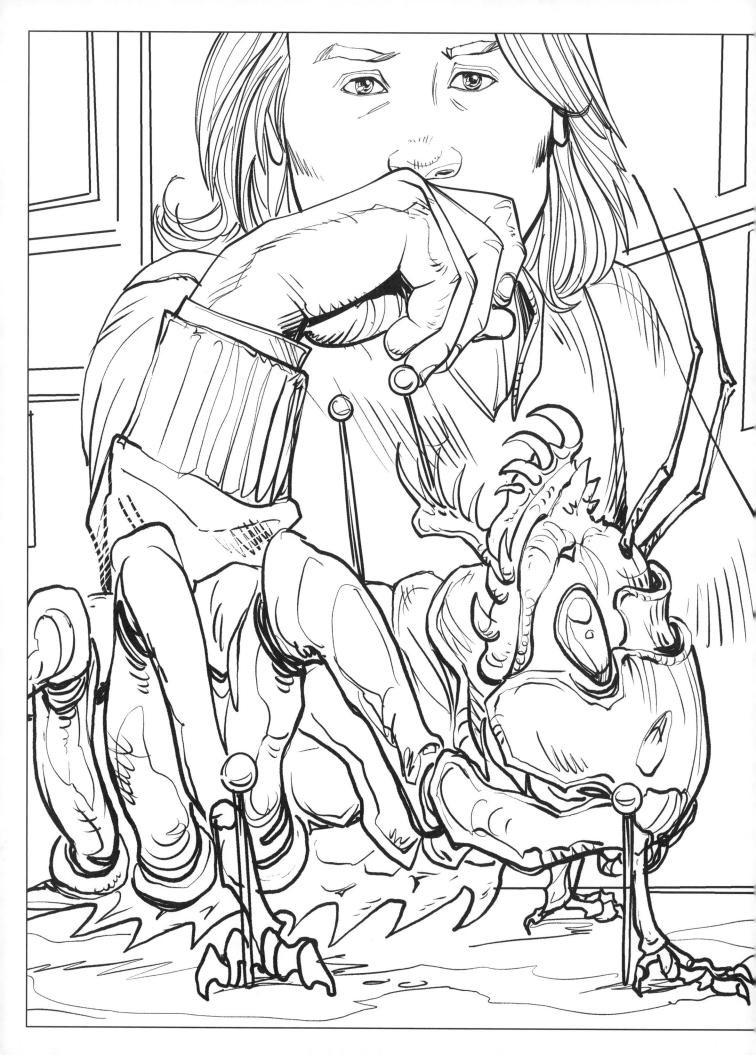

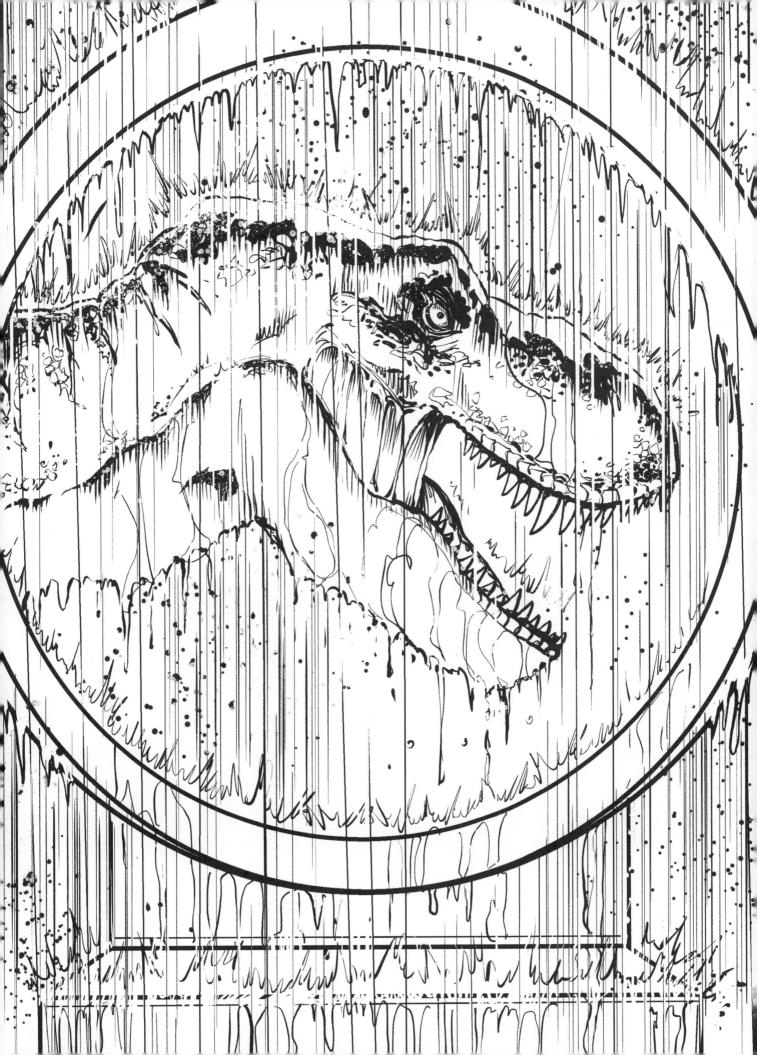

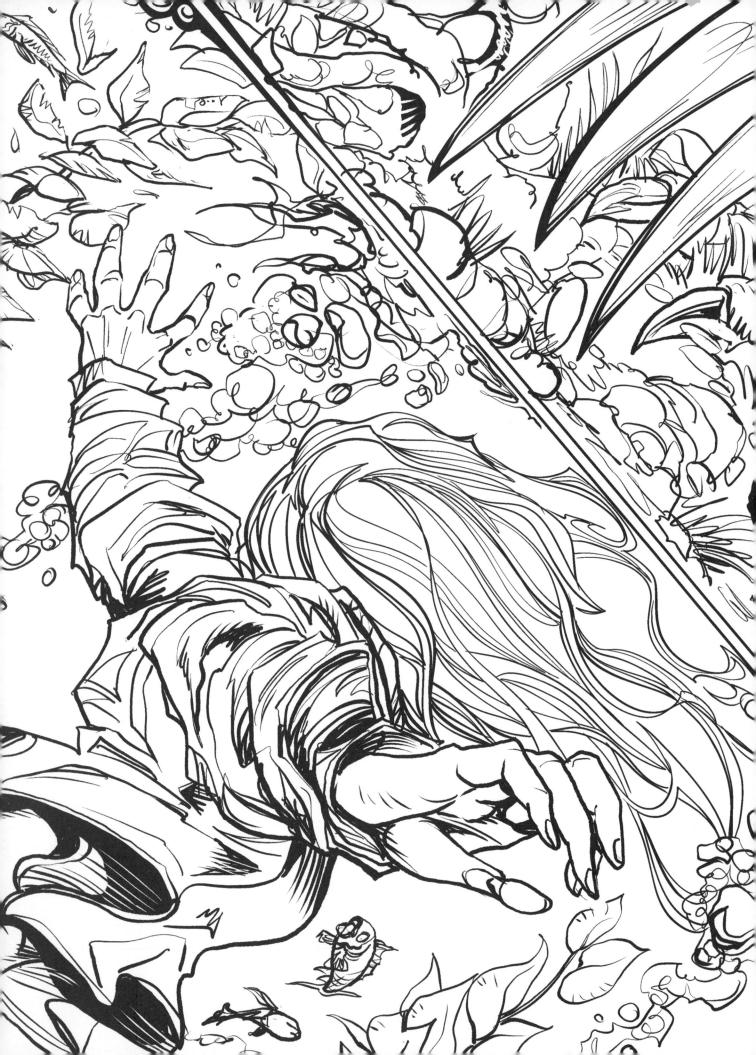

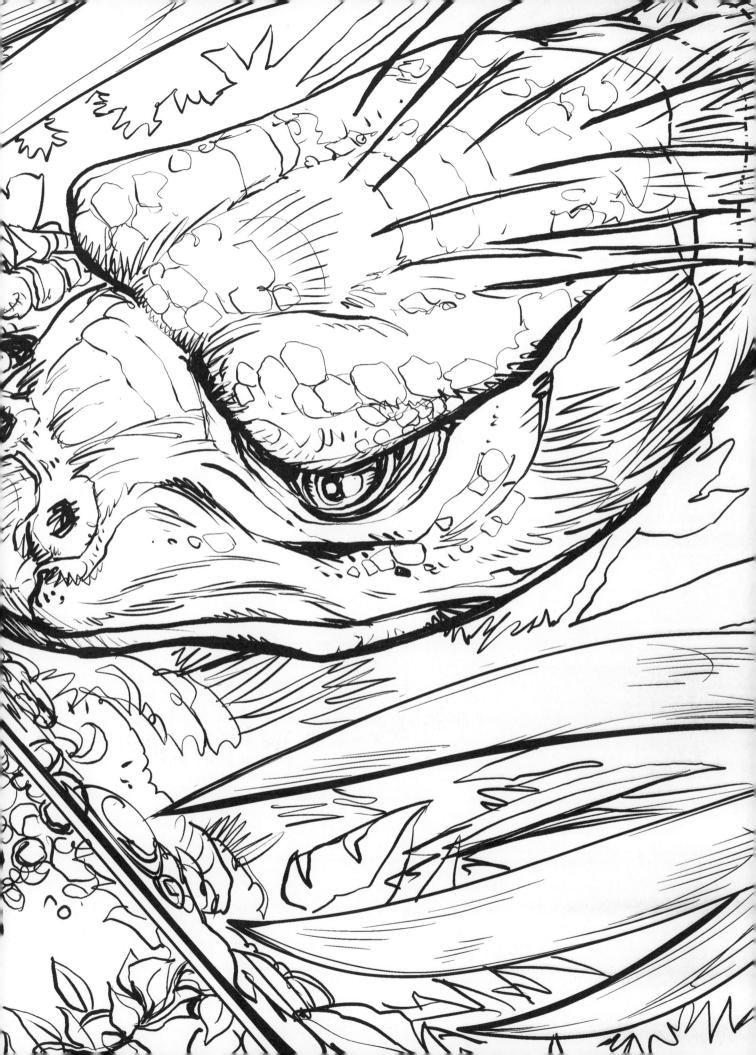

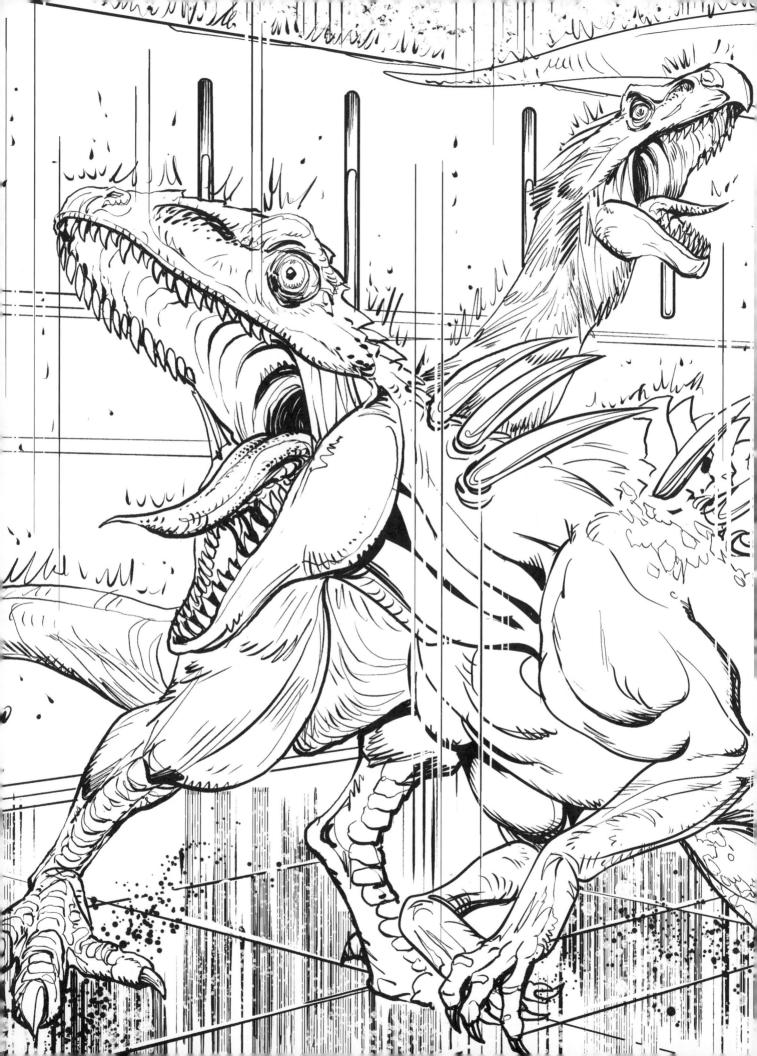

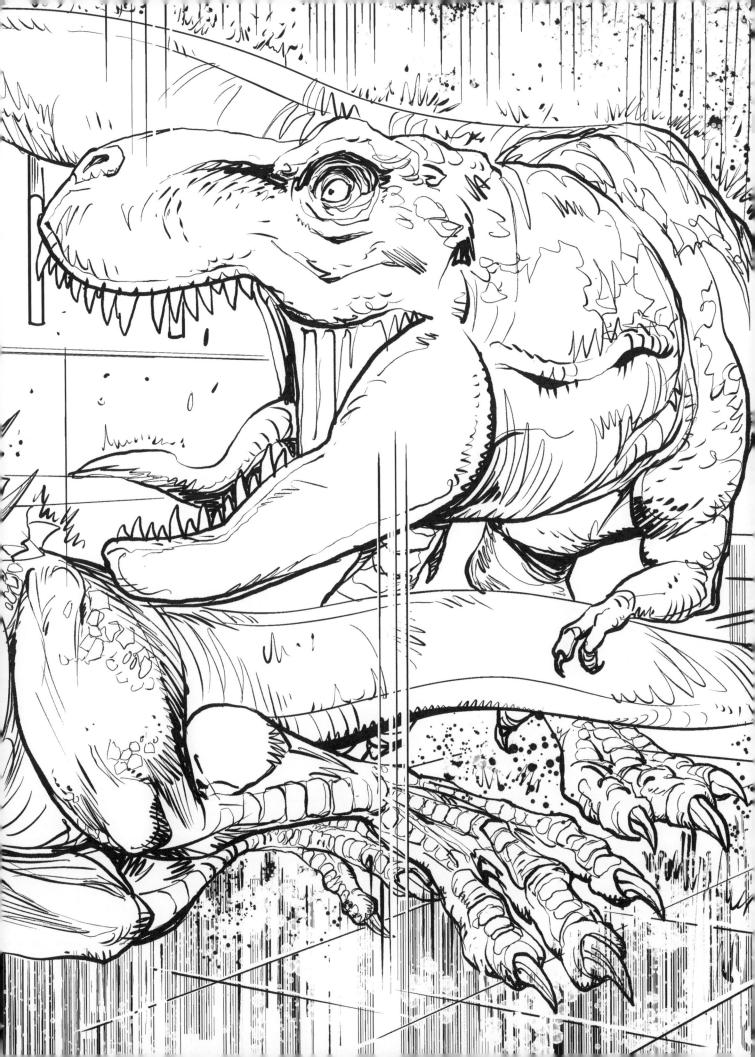

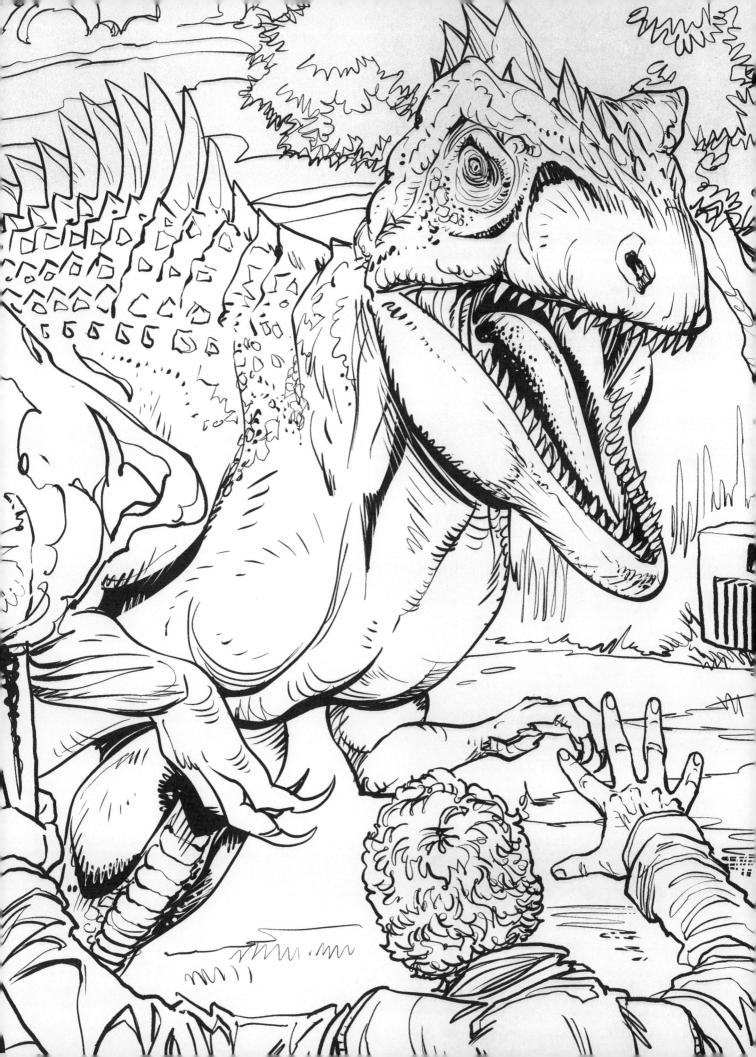

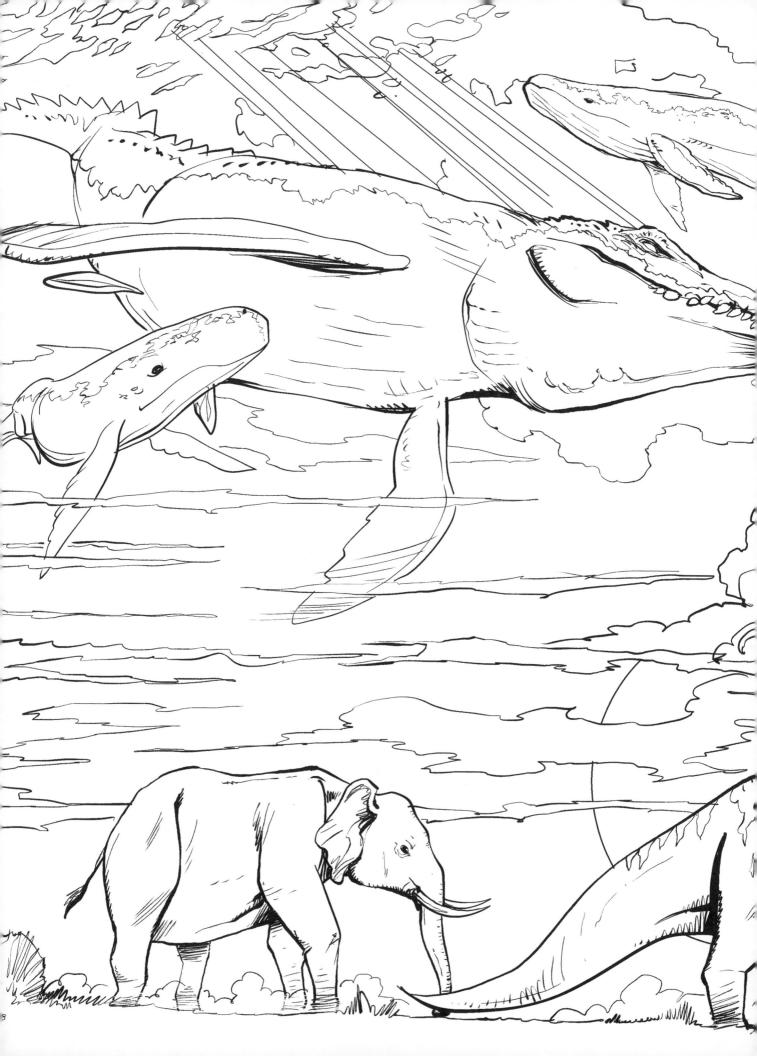

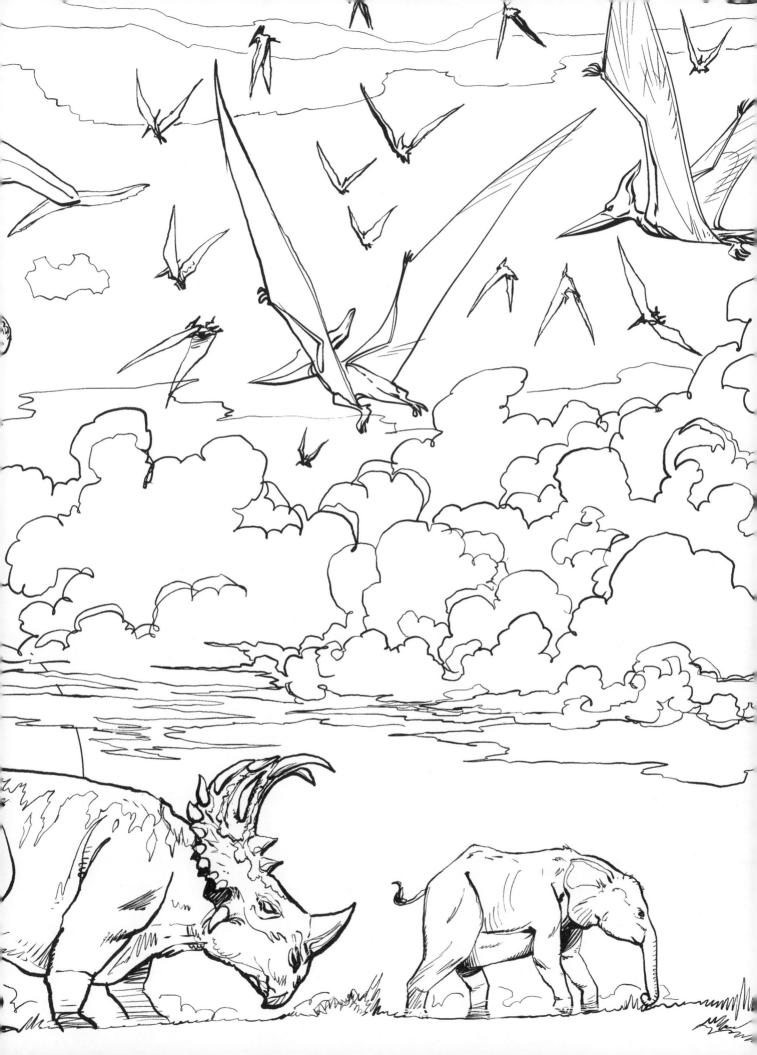

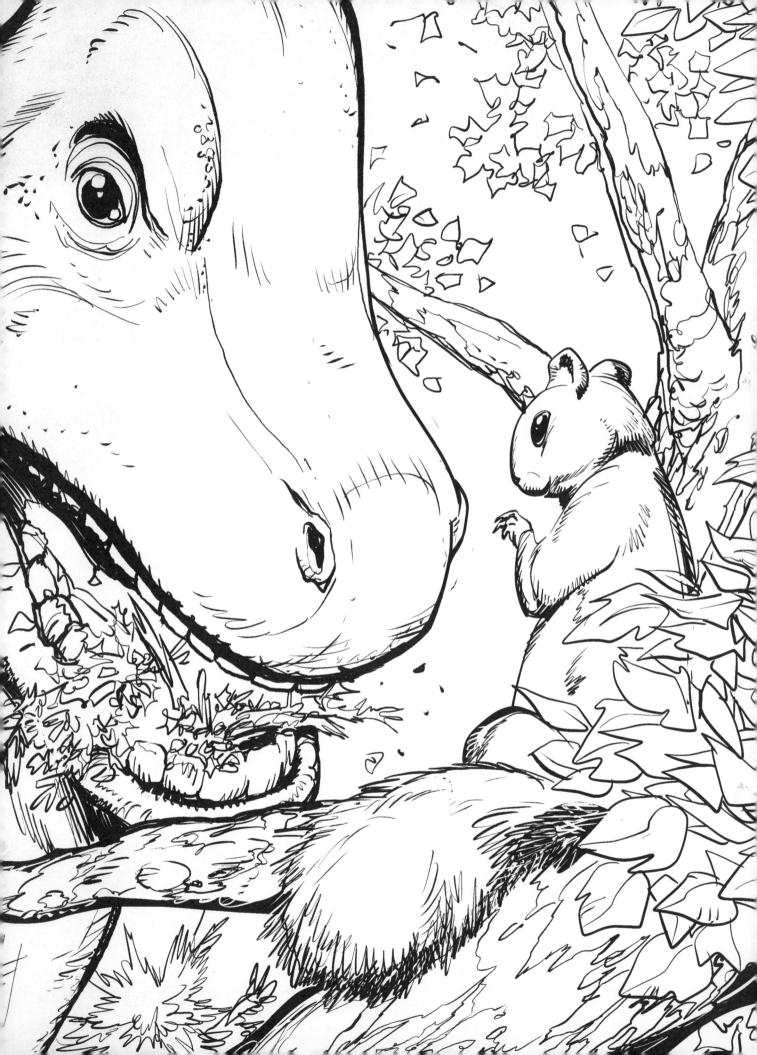